AMISH STYLE

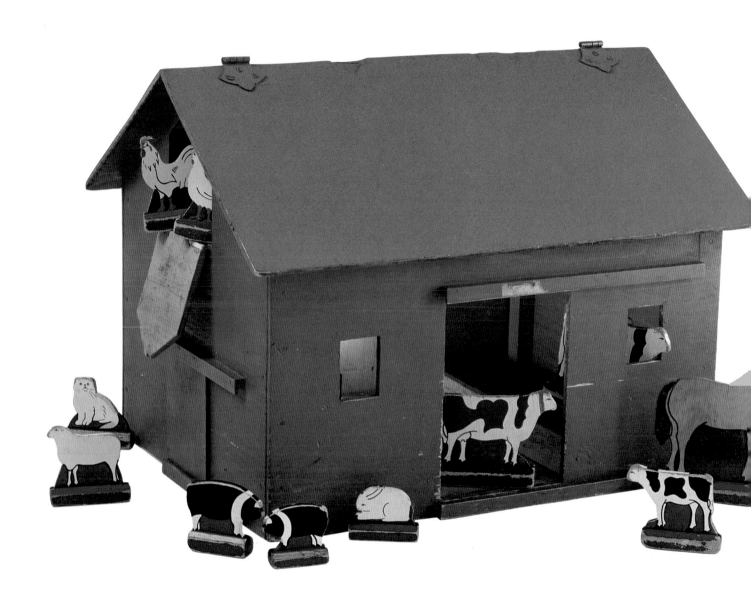

KATHLEEN McLARY

FOREWORD BY DAVID POTTINGER

INDIANA UNIVERSITY PRESS

AMISH STYLE

CLOTHING,

HOME FURNISHING,

TOYS,

DOLLS,

AND QUILTS

BLOOMINGTON AND INDIANAPOLIS

Library of Congress Cataloging-in-Publication Data

McLary, Kathleen, date.

 Amish style : clothing, home furnishing, toys, dolls, and quilts /

 Kathleen McLary ; foreword by David Pottinger.

 p. cm.

 Includes bibliographical references.

 ISBN 0-253-33622-8 (cloth). — ISBN 0-253-20820-3 (paper)

 1. Decorative arts, Amish. 2. Amish—Social life and customs.

 I. Title

 NK805.M35 1993

 745′.08′8287—dc20 92-43967

1 2 3 4 5 97 96 95 94 93

■ By their fruits ye shall know them.

Matthew 7:20

■ Set your affections on things above,
not on things on the earth.

Colossians 3:2

■ Man looketh on the outward appearance
but the Lord looketh on the heart.

I Samuel 16:7

CONTENTS

Foreword

David Pottinger

Collecting is a wonderful and interesting activity that leads us in many directions. For some of us, it's a personal way of furnishing our homes and, in the process of doing that, discovering a particular material that catches our interest—and a collection begins. Often we become so enthused by the hunt that we overpurchase and find that we have a need to dispose of certain items—and out of this circumstance, a dealer emerges. That is where I found myself when I first became involved in Amish quilts in the early 1970s. I was enamored by their stark

graphic beauty and at the same time curious about how this artful expression could be born of a plain and strict culture.

In 1977, I decided to make some major changes in my life, which led to my moving to Honeyville, Indiana, situated in the heart of Indiana's largest Amish settlement. Becoming a part of this community afforded me an unusual opportunity. It was the turning point in my attitude about the quilts and about what responsibility I had in expanding the collection. Never before had I purchased objects from those who had actually made them, or who were only one or two generations removed from the maker. With rare exception, the seller could tell me who made the quilt, where it was made, and the approximate date it was made. Helpful to this process was the fact that a large number of Indiana Amish quilts have the maker's initials and a date worked into the quilting. Similarities of piecing and quilting designs existed among family members and close friends, and by having this opportunity of contact, soon my focus began to change. When retrieving a quilt from an upstairs storage chest, I was always hopeful for something different and wonderful, but the ensuing conversation about who, when, and where, including many interesting side stories, was really what I looked forward to and appreciated. Oral history is an important aspect of Amish life, and recalling the circumstances in which a quilt was created gave both the storyteller and me great pleasure.

Quilts were certainly my first interest, but because I was in so many homes, looking through

closets, chests, and attics, other objects began to catch my eye. I then decided to expand the collection to include all textile objects made for home use. Clothing was an obvious inclusion, as all of the scraps from making clothing eventually found their way into a quilt or a loomed rug. Clothing led to hand-knitted stockings, mittens, and scarves. There were also the faceless dolls that were authentically dressed.

Last, but certainly not least, was the furniture. Many of the Indiana Amish families originally migrated from the Johnstown, Pennsylvania, area and brought with them the tradition of red and black painted furniture, stenciled in gold. Like so many of the quilts, much of the furniture could be attributed to a local maker by actual signature or by distinctive decoration.

The Indiana Amish community was established in 1841, but I have found very little documented material prior to 1870. Although a few earlier objects are included for comparison, the majority of the collection dates from 1870 to 1940. Having had the opportunity to assemble such a large group of regional material has afforded me great pleasure and enjoyment, which I hope will be passed along to all who read this book and visit the Indiana State Museum exhibitions.

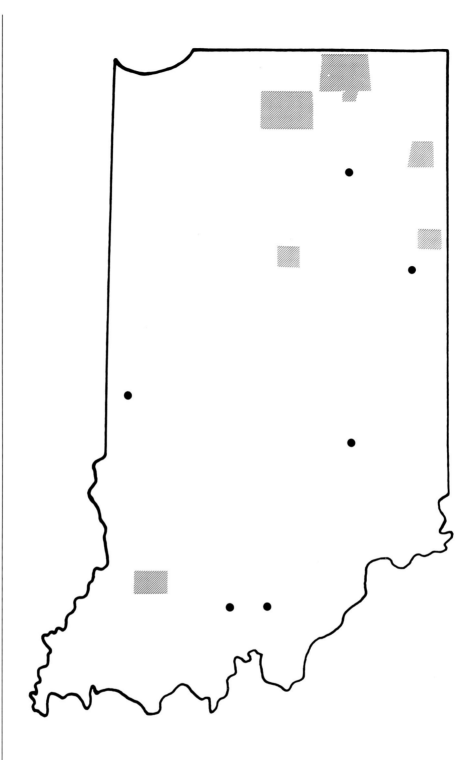

Outline of the state of
Indiana showing Amish
settlement. Shaded areas
indicate largest
communities.

Preface

When the Indiana State Museum Society had the opportunity to purchase the Indiana Amish Collection from David Pottinger in 1988, I was delighted. I had been directing tours to the Amish country for several years and had become fascinated with the countryside, the Amish people, and needless to say their unique quilts. As I began to catalog the collection, I greatly appreciated David's meticulous documentation of maker, owner, and family records as he acquired items from the Amish. But one thing that began to become very apparent was that little was in

print about the Indiana Amish communities. As I attempted to make comparisons with the well-documented and published Pennsylvania Amish communities, it became obvious that many aspects of the cultural artifacts differed between the two communities. I now had been given a new quest: define and document the Indiana Amish communities. Speeding right along toward my goal, I was immediately struck by another fact: all Indiana Amish communities were not alike. I have therefore limited this publication to the northern Indiana Amish communities, where the major portion of the Indiana State Museum's Amish collection was collected or traced back to.

The majority of the northern Indiana Amish communities are clustered primarily in the geographic area roughly comprising LaGrange and eastern Elkhart counties. Some twelve thousand Amish individuals, divided among approximately seventy-eight church districts, live there. Other Indiana Amish communities are located in Adams, Allen, Marshall, Kosciusko, Howard, Orange, Washington, Rush, Daviess, and Steuben counties. A new community has recently been settled in Parke County near Rockville. I am looking forward to being able to research and document these communities in the future.

Acknowledgments

I wish to thank the Indiana State Museum Society, for the purchase of the Pottinger Amish Collection and its support of this publication; Alice Reed, who chaired the Indiana State Museum Society's Fund Raising Committee and who believed in me when I took the dream of the Indiana State Museum's acquisition of this outstanding collection to the ISM Society; Dr. Richard Gantz and the collections staff at the Indiana State Musuem, for their patience and for allowing me the time to complete this project; Dick Spahr and Don Distel of Spahr

Photography, for the color photography; Rick DeCroes, for the black and white photography; and Karen Yohler, for the line-drawn illustrations and map. Special thanks go to collections manager Linda Badger, conservator Jennifer Hein, and lab technician Margaret Bennet, for helping me to meet deadlines. I am also indebted to those volunteers who have helped research, catalog, and conserve this outstanding collection: Martha Bushman, Dorothy Mussett, Pat Radel, Polly Rowe, and Helen Wise.

AMISH STYLE

Amish religious books are printed in German. The church service is conducted in German also.

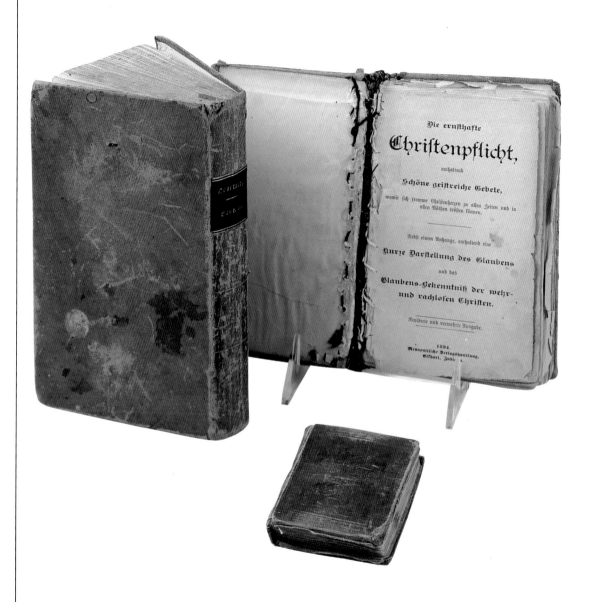

THE AMISH WAY OF LIFE

The Amish sect descended from the Protestant Reformation through the Swiss Brethren Anabaptists. The Anabaptist movement spread to Germany and the Netherlands. In 1536, as Martin Luther was challenging the teachings of the Catholic church, Menno Simon, a young aspiring Dutch priest, was also struggling with the church's doctrines. From Menno's belief that God was the highest authority in all matters of faith, the Mennonite church was formed.

One unifying belief of the Anabaptists who divided themselves from the Catholic church was that

baptism must occur upon profession of faith rather than at birth. Menno's new church, however, included further tenets, which set his sect apart from the others. The chief tenets of this newly formed religious group were the utter separation of church and state; avowal of pacifism (no participation in war, military training, and other aggressive acts, including court suits); refusal to swear oaths; and church discipline. For their adherence to such principles, the Mennonites were vigorously and violently persecuted by authorities in Switzerland, the Netherlands, and Germany.

A young Mennonite bishop, Jacob Amman, became concerned in the 1690s that the Mennonite church was becoming too lenient in both ritual and discipline. He believed that the use of ban and avoidance (*Bann und Meidung*) in administering church discipline extended beyond the yearly communion table and into daily social life. The issue of shunning ultimately became the dividing point between the Mennonite church and Jacob Amman's followers, called Amish. Jacob's beliefs in regard to modesty, plainness of dress, and separation from the world, as reflected in clothing and in beard and hair cutting, have provided the most visible differences between the Amish and others.

The Amish first migrated to America in 1714. Settling in William Penn's Pennsylvania, open to Quakers and other religious groups persecuted for their faith, they lived primarily in Berks, Somerset, and Lancaster counties. As their communities grew, however, so too arose the need for more land. Four

Amishmen scouted the western states and determined that Indiana was a good place to settle. In 1841, four families moved to Elkhart County, Indiana, beginning the state's rich Amish history.

As with other religions, differences of opinion among the Amish continually cause groups to break off from the original Old Order Amish church. A major split occurred in the Indiana Amish church in 1854 when the Amish Mennonites felt that modern clothing and ornamentation were acceptable and that members could hold public offices, own retail and industrial businesses, and attain an education beyond the eighth grade. The recently formed Beachy Amish have allowed members to drive automobiles. Consequently, the Indiana Amish in the northern communities comprise, not one uniform religion, but several separate churches living in harmony.

The Amish consider themselves a "peculiar people," transients in this material world awaiting the Resurrection. United by shared beliefs, they turn their separation from the outside world into a practical religious principle. So inseparably does theology permeate and prescribe the details of their daily life that sociologists describe the Amish as an enclosed "little community," distinguished by custom as well as by doctrine. What is perceived as a quaint agrarian way of life is actually a matter of following a moral directive to till the soil as a means of staying close to God and of safeguarding the group's self-sufficiency. Conservatism and communal conformity are vital to Amish identity. Each church district (composed of approximately fifty households) main-

tains and enforces its own regulations covering all aspects of spiritual and material life. When an issue cannot be clearly decided by biblical interpretation, the Amish resort to precedent with the maxim: "Let the young brethren be as the old brethren, and the young sisters be as the old sisters." Tradition and strict adherence to rules thus define the Amish way of life; they have also been the main theological issues throughout Amish history.

Each Amish district is normally presided over by four clergymen: a bishop, two preachers, and a deacon. The bishop is the spiritual head of the district. He presides at weddings, funerals, baptisms, communion services, and excommunications. Preaching is not his primary job. He is selected to prescribe and enforce the rules and otherwise hold the community together.

Rules are not written; they are whatever the bishop interprets the Scriptures to mean. Rules, therefore, may change as one bishop replaces another. For example, a new bishop may feel that riding a bicycle is too worldly, whereas his predecessor had allowed it. Members may move from one district to another if they disagree with the bishop's interpretations. It is not uncommon for a family to move to either a more conservative district or a more liberal district, allowing themselves to feel comfortable with the directives of their religious leaders.

Bishops in the Amish community are believed to be selected by man and God. The district's preachers and deacons each take a Bible from a table. A biblical quotation written on a piece of paper is in-

serted in one of the Bibles prior to the selection. The person who draws the Bible with the paper inside becomes the new bishop.

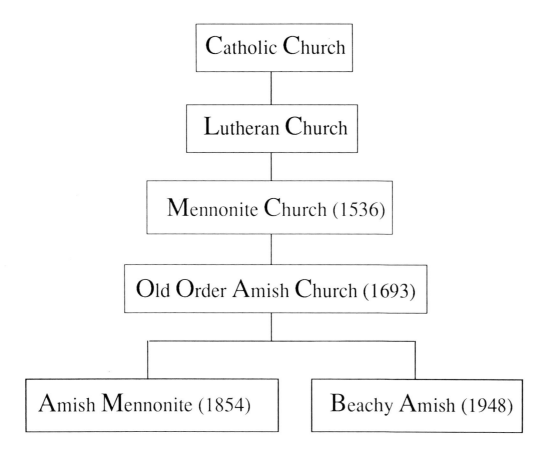

The children of the Old Order Amish are raised in strict accordance with Amish principles, but as each individual nears adulthood he or she makes a conscious choice to join or not to join the church. In those years between childhood and adulthood, the youth are encouraged to explore the outside community. They may drive cars, dress in contemporary fashions, and generally "run about." "Running about" allows the young to experience what they will give up as Old Order Amish. By adulthood (ages

eighteen to twenty-one) or marriage, a choice must be made. The majority join the church.

The practice of shunning is a very important aspect of the Old Order Amish church. If an individual joins the church and later decides that he or she cannot live by church rules, family and neighbors will not be able to eat, drink, or socialize with that person. Community members are not shunned in the LaGrange and Elkhart communities if they determine that they would feel more content by joining the Beachy Amish or a Mennonite church. (This is not true in a few very conservative communities in eastern Indiana. There, not to join the Old Order Amish church results in shunning.)

Families with ten to twelve children are not uncommon in Indiana's northern Amish communities. Eight children is the norm. Because of the type of farming each family does, large families are looked upon as an asset—more hands to do the chores.

The Amish farm family typically includes the parents of one of the spouses. When the elder couple is unable to manage the farm or wants to retire, one of the children, a son or daughter, buys the homeplace. A smaller "dowdy," or "grandfather house," is added to the homeplace. The parents move into the smaller quarters, allowing the younger generation to live in the main structure. The elder couple continues to assist on the farm, not experiencing the uselessness felt by some elderly people in the "English" (the Amish term for all that is non-Amish) world.

The number of Amish families who initially came to America was very small. Almost all Amish

can trace their genealogy back to those original families. A directory is published periodically that lists all members' names and dates of birth, marriage, and death. This detailed record is useful in planning for marriage. The Amish, who seldom marry outside their religion, are forbidden to marry first cousins. Second-cousin marriages are discouraged. As in other cultures with closed gene pools, however, medical complications have arisen. To avoid further problems, the Amish transport groups of young men and women to communities in other states to enhance the possibility of meeting future spouses who are not closely related.

The Amish are an agrarian people. All live on farms, even if outside employment is necessary to support the family.

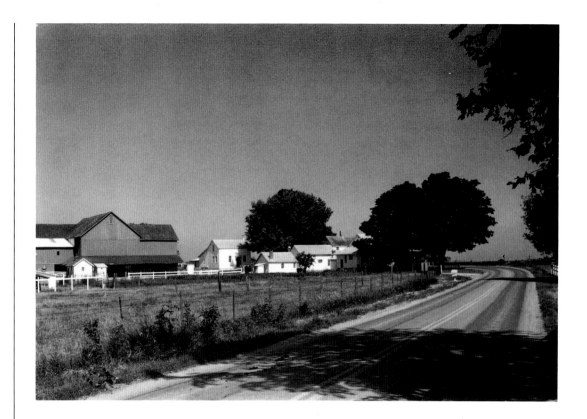

Field implements are horse-drawn. Typically, dark horses are used for buggies, but draft horses of all colors are used in the fields.

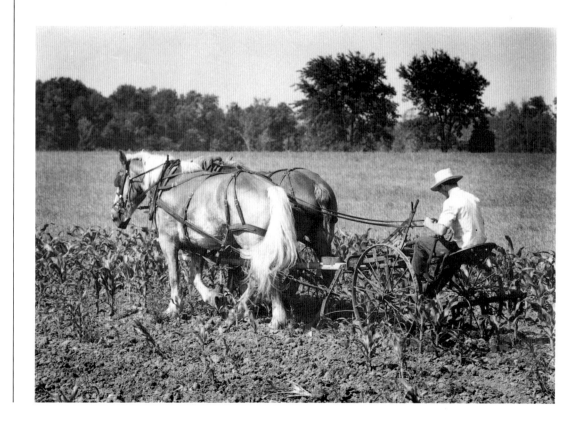

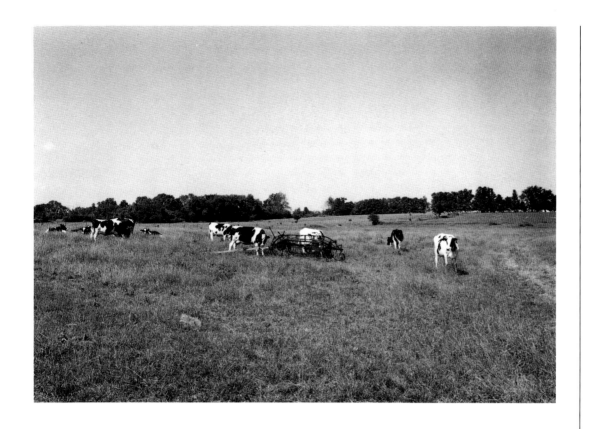

Milk is one of the several agricultural products which the Amish farmers provide to Indiana's economy. Amish dairy herds are smaller than those of the "English" (non-Amish) farmers. The herd is only as large as can be hand-milked twice a day.

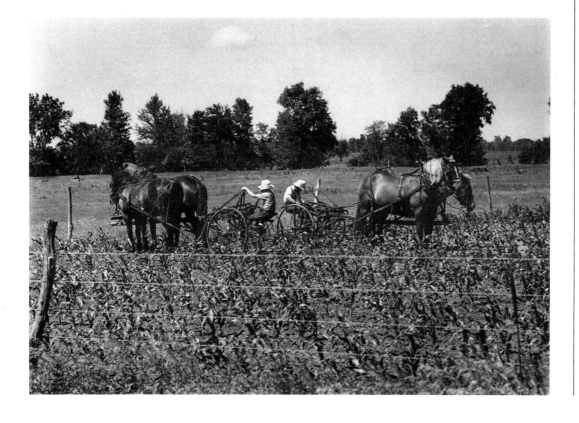

These two boys are cultivating early summer corn. Amish children and women help in the fields.

Horse-drawn buggies are the Amish mode of transportation. Buggy styles differ among the various Amish communities.

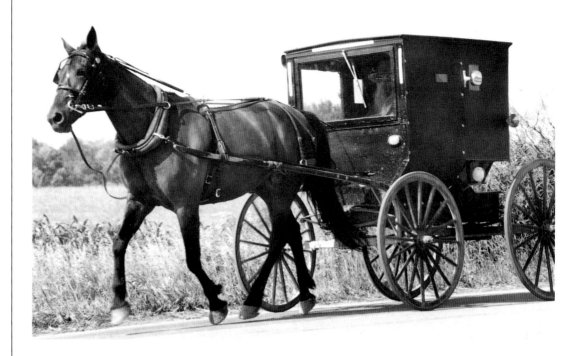

Many northern Indiana roads have a wide brim to accommodate the Amish buggy traffic.

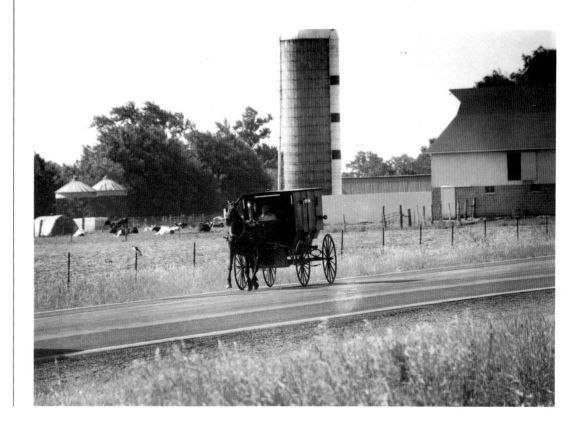

A small house is built next to and connected to the main house to provide a place for the elder parents when they retire from the farm.

Church wagons move the benches needed for the next Sunday's service from home to home. The Amish do not have a separate structure for religious services.

Calling cards were once
part of the formal social
visiting among the Amish
on those Sundays
when they did not
attend church.

AMISH STYLE

The distinctive dress of the Old Order Amish is one way the church community indicates its separatism. Children's clothing mimics the adult clothing of the community.

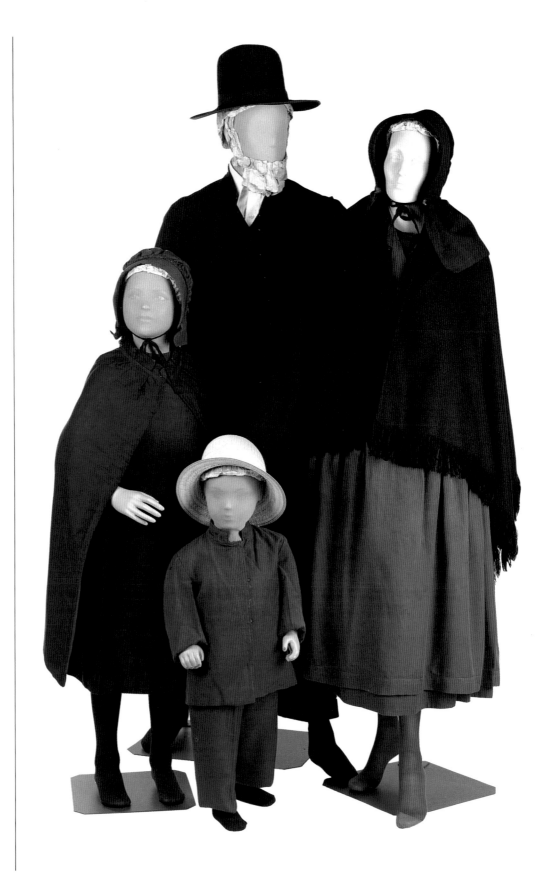

CLOTHING

The distinctive clothing of Old Order Amish reflects a belief that simplicity and uniformity of style are essential for Christian discipleship. Style of clothing alone cannot make one Amish, but it does promote group unity and identification. To outsiders, plain dress is the most easily discernible indicator of Amish affiliation and of not conforming to worldly standards. Clothing varies little within a given district, but one may find pronounced differences in color, cut, and shape of apparel among various Old Order Amish groups.

In the early years of the Anabaptist movement, stress on humility, simplicity, nonconformity, and modesty did not result in a standard form of dress, but in consistently plain and unadorned clothing. Dress followed contemporary peasant styles. But as group uniformity began to be threatened by increased interchange with the "world," emphasis on specific modes of dress began to surface as leaders, sensing a breakdown, reached for ways to reinforce their groups' identities. The two scriptures considered the most influential guidelines followed by the Amish are "Whose adorning let it not be that outward adorning of plaiting the hair, and of wearing gold, or of putting on of apparel; but let it be the hidden man of the heart, in that which is not corruptible, even the ornament of a meek and quiet spirit, which is in the sight of God of great price" (I Peter 3:3–4) and "In like manner also, that women adorn themselves in modest apparel, with shamefacedness and sobriety; not with braided hair, or gold, or pearls, or costly array" (I Timothy 2:9).

Women of the Old Order Amish faith avoid worldly ornamentation in their outward appearance. They do not use buttons on their clothing or wear jewelry, including wedding rings. Straight pins were traditionally used to fasten garments; today, velcro can be found on many clothing items. Female children, because they are not church members, may use buttons and zippers on their clothing. Dark blue, black, purple, brown, and other somber hues make up the palette of the adult women's clothing. Girls' dresses can be a variety of colors, including the pastels.

A woman's daily clothing includes three required components: cape, dress, and apron. The cape is derived from the kerchief that was worn by sixteenth-century European women. Originally a square piece of fabric folded into a triangle, the present-day cape is cut and sewn in triangular shape. Northern Indiana Amish wear the cape crossed in front. The cape provides added modesty by concealing the neck and the form of the bosom. A collarless, long-sleeved dress with pleated or gathered skirt is covered with a pleated or gathered apron, usually of the same fabric as the dress. Women may not have visible pockets on their dresses, but pockets are sewn on the front of the skirts, where they are hidden by the apron. The apron, like the cape, is considered a required item in the LaGrange County communities, although more and more Amish communities do not require the apron. The apron and cape for daily use match the color of the dress. For church and other formal activities, a white cape and apron are worn.

Construction techniques of the Amish women's clothing were not that different from those of the "English" communities during the 1700s and 1800s. However, inner lining and shaping continued to be used in the construction of Amish wear far later into the twentieth century than was the case among the general population.

Young girls wear a dress and an apron. The dress has a back closure, differing from the women's front dress closure. The apron is a full, sleeveless covering, with one fastener at the top back; a fabric

matching the dress is usually used for everyday wear, and white for church. Pleats and tucks are used extensively in children's wear, not as decoration, but to allow maximum usage. Tucking at the shoulders, upper arms, bodice, and hemline can be let out or removed as the child grows. And because the Amish have large families, the tucks can easily be replaced so that the next child can use the same garment.

The black bonnet and the head covering, or prayer cap, are required apparel for Amish women when in public. Probably the most recognized symbols of the Old Order faiths, they, too, have a scriptural basis: "Every man praying or prophesying, having his head covered, dishonoureth his head. But every woman that prayeth or prophesieth with her head uncovered, dishonoureth her head; for that is even all one as if she were shaven" (I Corinthians 11:4–5).

Bonnet styles vary from place to place. In many cases the bonnet style indicates an Amish woman's community. Northern Indiana Amish women typically wear the Midwest-style bonnet. Because people marry into communities elsewhere or move from community to community for other reasons, however, it is not unusual to see in Indiana a stand-up crown or slat bonnet typically worn in the Pennsylvania communities.

The women and girls do not cut their hair but wear it parted in the middle, pulled severely back from the face, and twisted in a bun at the nape of the neck. The prayer covering on the back and top

stand-up
crown bonnet

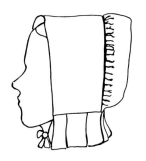

Midwest style bonnet

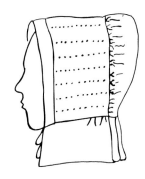

slat bonnet

of the head is worn by all Amish females regardless of their marital status. While the design of the covering may vary from district to district, certain elements are generally constant: made of white or black organdy or net and having a cap shape. The width of the brim is an indication of how conservative or liberal the wearer is. The wider the brim, the more conservative. String ties also indicate a more conservative order.

In northern Indiana communities, married women and church members wear the white cap at all times, whereas unmarried females wear a black covering to church and on other formal occasions. Other Indiana communities follow different practices. For example, Adams County Amish women wear a black cap all the time, and Daviess County women may even use a black chiffon scarf for everyday wear. The details on the cap or covering also vary from community to community. Elkhart and La-Grange caps have fine pleating on the crown and a small bow at the back neck. The Daviess County

caps have a center back seam and four small pleats at the bottom of the crown.

Little girls, up to the age of twelve, often wear the mantle, or "mandlie," in cold weather. The mantle is a long, cape-like outer garment, usually made of wool, with a warm inner lining. Tailored and sleeveless, it is shaped to be fairly close-fitting and has hook-and-eye, button, or snap closures. A cape collar or stand-up collar is used.

Older girls and women wear capes or shawls during colder weather. The black wool shawls are square. How these squares are folded and worn varies from place to place. Indiana women fold the shawl lengthwise. Coats may be worn under the shawls, but rarely do women wear coats. Although wool capes are occasionally worn in Indiana, shawls appear to be preferred.

Traditionally, Amish women hand-knit stockings, gloves, scarves, and other clothing pieces. Today, commercially produced items are used. The Amish woman must be wife, mother, gardener, field assistant, cook, seamstress, and laundress. As certain articles of clothing become cheaper and more readily available to the community, it is easier, and a better use of time, to buy them.

Traditional wedding stockings have been a casualty of the trend to purchase ready-made articles. The special wedding stockings sported a highly decorative band at the top of the leg above a plain lower ankle and foot. The band included contrasting stripes, patterns, and scallops. This contradiction to other Amish clothing was allowed because the band

was above the hemline and therefore only the husband would see it in the privacy of the home.

Men and adolescent boys wear dark suits: coats without lapels; suspenders; broadfall pants worn with white or pastel shirts; black shoes; and black felt or straw broad-brimmed hats. Men wear a frock coat with a notch collar; boys' coats are of the sack style. These styles were worn by the general population during the eighteenth and nineteenth centuries.

Many aspects of the men's clothing are a direct result of the nonviolence tenet of the Amish. Men in most communities do not wear buttons on their coats or wear belts. The prominence of both these features on the military attire of the sixteenth and seventeenth centuries is an obvious contrast. Suspenders and snaps fulfill the functions of belts and buttons on Amish men's trousers and coats. Northern Indiana Amish generally use the "X" suspender having leather tabs which attach to the trouser waistband.

The broadfall is considered a more modest type of men's trousers. The broadfall has an inner center button which fastens the two sides together and is concealed by a front flap at the waistband. The trousers can be made of cotton, wool, or blue denim. They have no hip pockets, but front pockets are concealed under the front flap. A manufacturer in Middlebury, Indiana, is a regional supplier of broadfall trousers.

The wide-brimmed black felt or straw hat is worn by most Old Order groups. A brim width of

three and three-fourths inches is standard. Bishops may wear hats with wider brims than those worn by their congregations. Whether or not the crown is creased or rounded is a district preference.

Men's hair, worn full, is cut at the collar line with shorter bangs at the temples. The hair is combed down in all directions from the crown in what many call a "bowl" cut. Men shave until marriage and then grow a full, uncut beard. Mustaches are forbidden because of the association with earlier military styles.

The men's caped greatcoat is a carryover from seventeenth- and eighteenth-century clothing styles which the Amish have chosen to retain, though it is beginning to disappear in most communities. Bishops in a few districts are the only ones today who wear this heavy coat. A blue denim jacket with snaps or hooks and eyes is the common winter wear for most Amish men. The jacket does not have outer pockets, but usually an inner patch pocket instead.

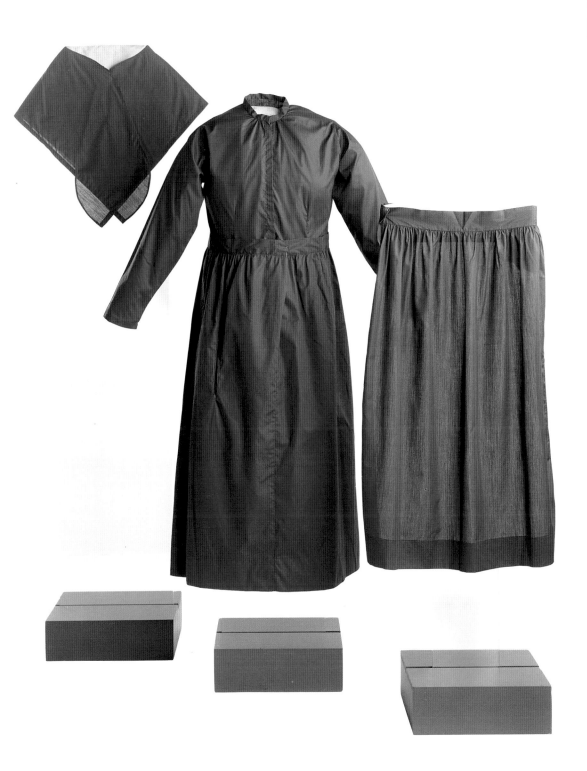

Women's clothing includes three required components: one-piece dress, apron, and cape. The cape and apron are considered necessary for modesty.

The bonnet and prayer cap, required apparel for those Amish women who have professed their faith, are primary symbols of group identity. Shown here are an adult black bonnet and a child's wool bonnet. Children may wear bonnets of other colors, but black bonnets are the most common.

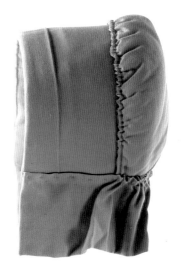

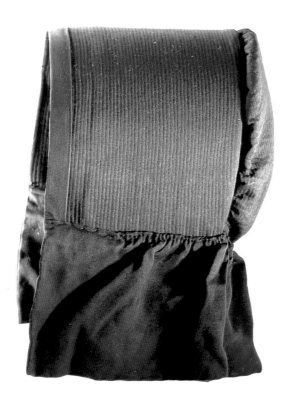

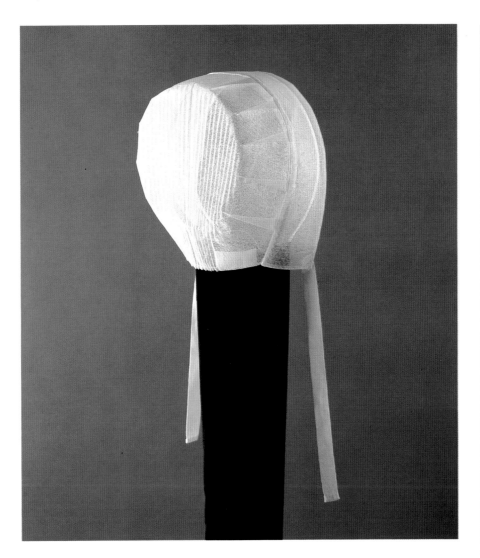

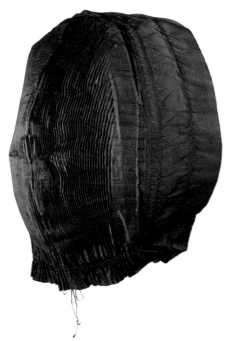

A white prayer cap is worn regardless of marital status except at church services, where unmarried females wear a black cap.

The black wool shawls in the northern Indiana Amish communities are folded into a rectangle. Ohio and Pennsylvania Amish women fold the shawl into a triangle.

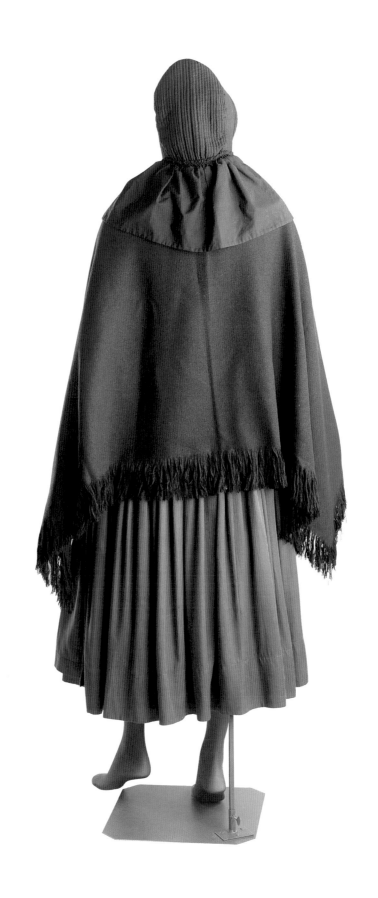

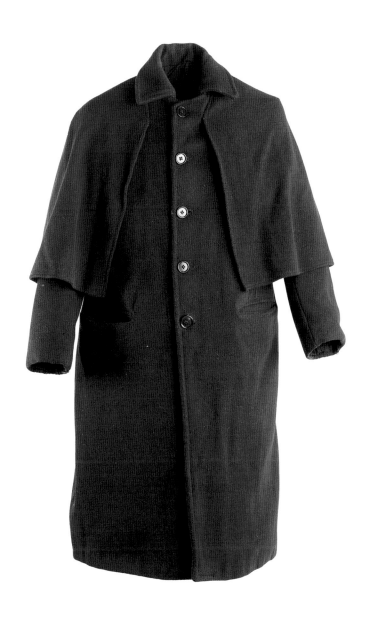

Traditionally, men wore eighteenth-century-style caped overcoats, or greatcoats, made in the home. Levi D. Christner's wife, Goldie Eash Christner, made this black wool coat. His daughter, Susie, remembers Levi turning the cape up over his head on cold winter days. Greatcoats have now given way to plain, commercially made denim coats in most districts.

Inner lining and shaping in Amish garment construction continued into the twentieth century.

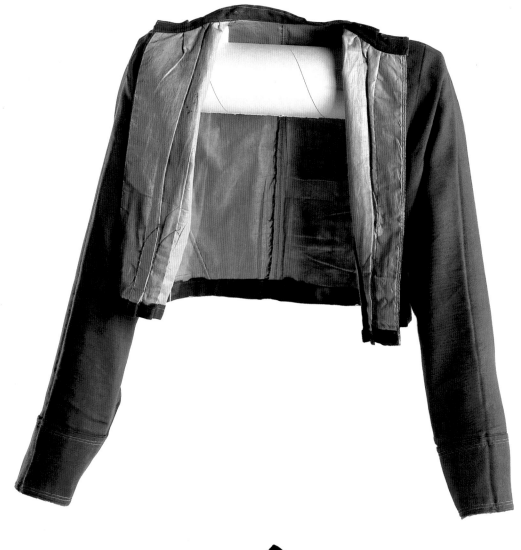

Traditional wedding stockings are especially colorful, with bold stripes and scalloped edges on the bands at the top. Note that the ornamental trimmings on these stockings would not be seen below the hemline of the older girls' dresses.

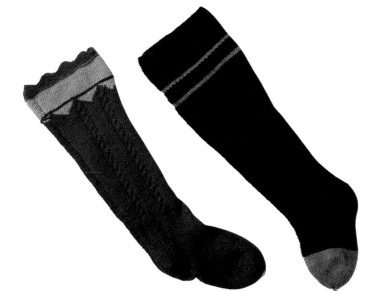

AMISH STYLE

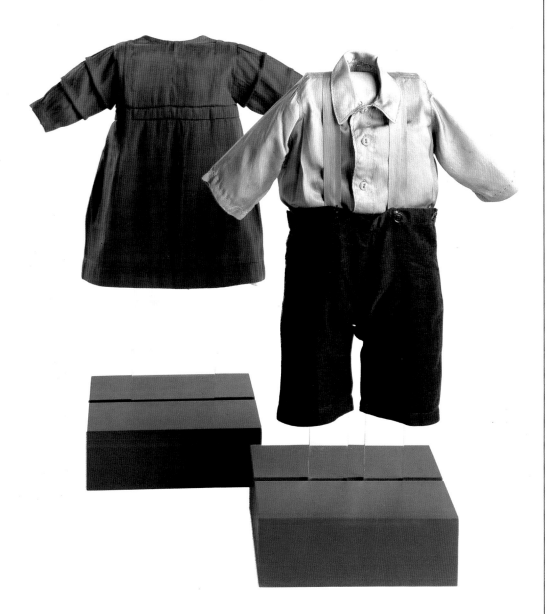

Toddlers' clothing, with broadfall trousers and plain fabrics, reflects the church rules.

Boys wear broadfall
trousers and a sack
jacket. Girls wear a full
apron over a dress.

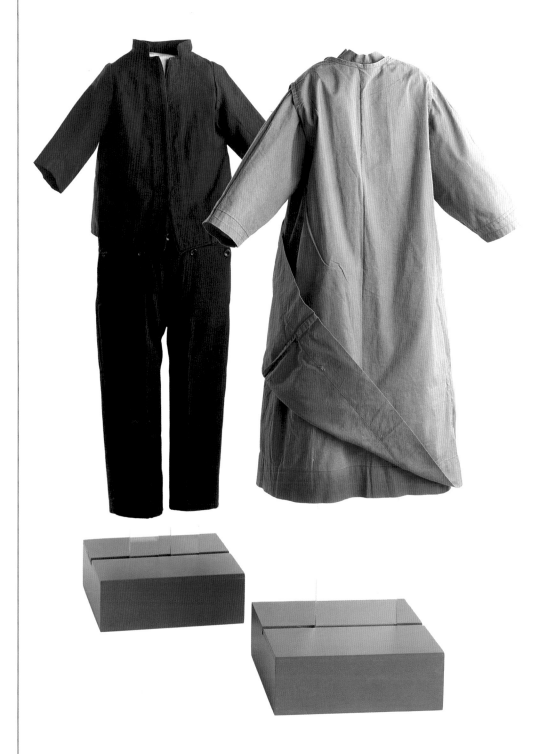

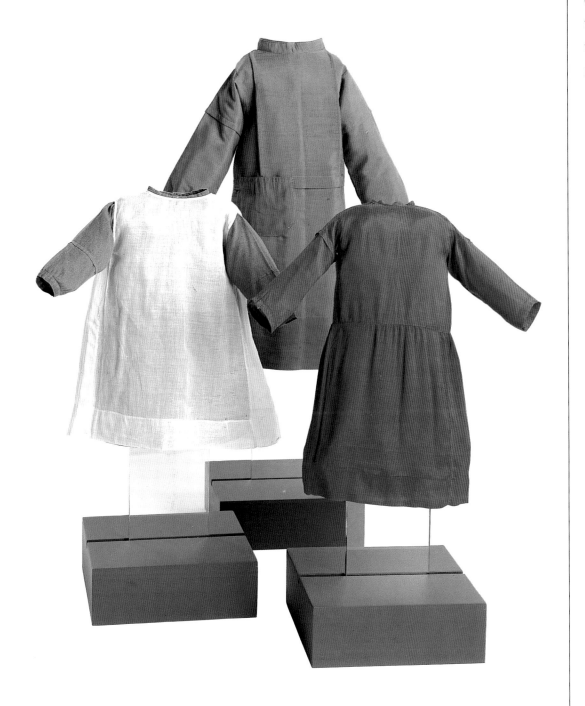

The colors of children's clothing may be chosen from a broader palette than that used for church members' clothing.

Girls' dresses are usually fairly straight in front with pleated backs. A pocket may be sewn in the front where it will be covered by the apron.

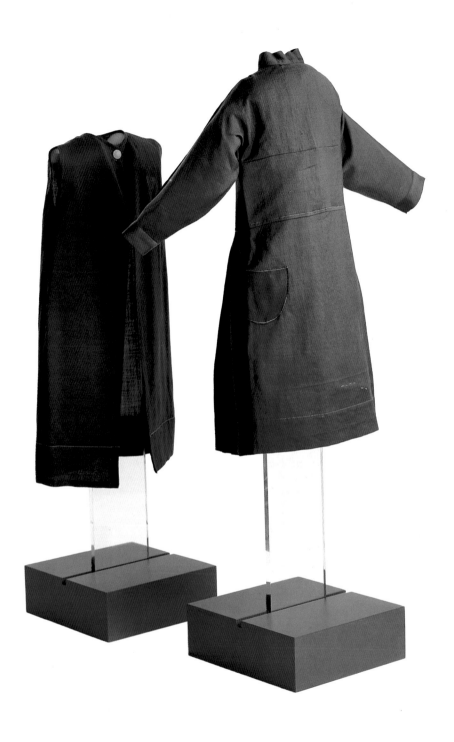

AMISH STYLE

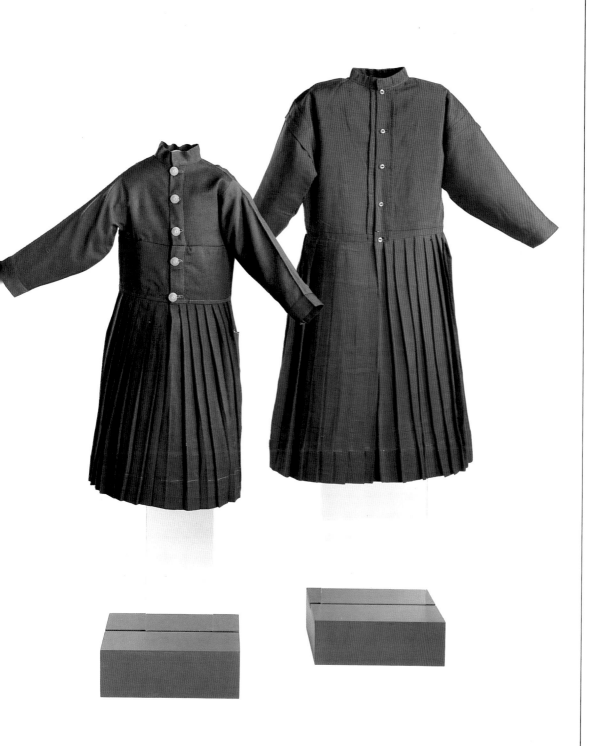

Young girls may wear buttons, but adult female church members are forbidden to do so.

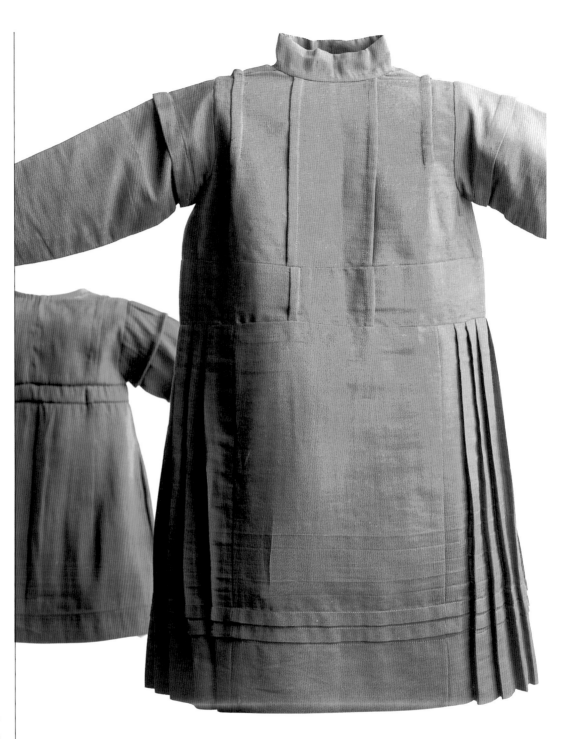

Note the tucks, tuck lines, and pleats that allow this dress to expand as its wearer grows.

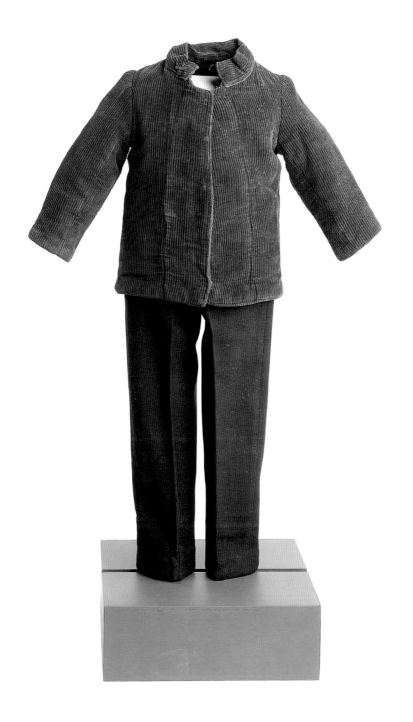

Many boys wear the sack coat, without pockets, to church. This style is usually limited to less formal wear for the men.

Little girls often wear the mantle, or "mandlie," in cold weather. Older girls and women wear coats, capes, or shawls.

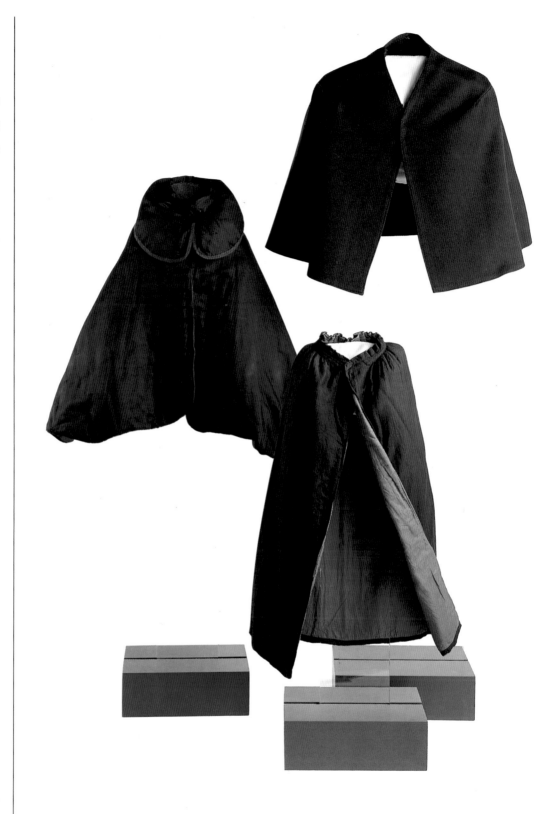

AMISH STYLE

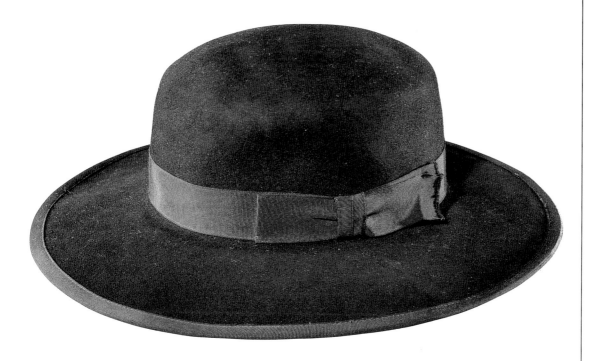

Shown here is a boy's
black felt hat, usually
worn for church or other
formal occasions.

A child's bentwood rocker
sits on a crocheted rag
rug. Area rugs are placed
on the wood floors
throughout the
Amish house.

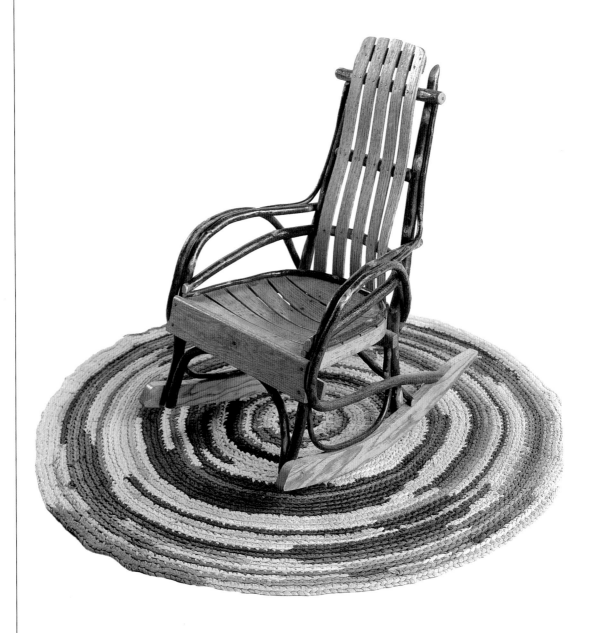

HOME FURNISHINGS

The Amish do not inherit their parents' estates. After the death of both spouses, and if the farm had not been purchased earlier by one of the children, a sale is held to distribute the material holdings. The sale can be open to the public or, if the family chooses, it can be closed to all but family members. At a family sale, members bid against one another for the items they want.

The Amish home is plain and does not have modern conveniences. The houses are large compared with "English" houses, for not only do they

house the multigeneration family, but they also serve as a church. The Amish do not use a church building, but rotate the site of the biweekly service among the membership of the district.

The furniture is traditionally natural wood or painted and is typically made in the community. The northern Indiana Amish brought with them from Pennsylvania the tradition of black and red painted pieces, though variations are found in red and green. Many of the furniture makers made a habit of signing their pieces or used a distinctive design or pattern so that it is not difficult to identify the maker.

The church service is held on Sunday and includes a three-hour service followed by a meal. Benches are brought to the site of the service, which may be held outdoors in nice weather. In winter and inclement weather, the furniture in the house is removed to make room for the benches.

The houses are designed to allow persons seated throughout two or three rooms to view one central point. Large arches separate the rooms. The women and very young children sit in one room, and the men and older children in another. Teenage girls and boys also have specified sitting locations. The preachers stand without a pulpit in front of the group. The service is in German, as are the Bible and song books.

After the service, the entire district membership, sometimes in as many as three shifts, eats the prescribed lunch meal. Small talk may follow: then gradually all will get into their buggies to go home or to visit friends and neighbors. In the evening, a

young people's meeting is held, with singing of both German and English hymns.

Denouncing commodities which would make them dependent on the outside world, the Amish do not allow electricity, telephones, or gas lines to be installed in their houses or barns. It is not modern technology that is at issue; rather, it is the connection, or line, to the outside world that is objectionable. This rule has a direct influence upon their livelihood. State laws require milk for drinking to be grade A. To be classified grade A, milk cannot be exposed to air from the time it leaves the cow until delivery to the dairy. New electric machinery processes grade A milk as required. However, Amish farmers hand-milk their cows, collect the milk in open buckets, and pour the milk into five- to eight-gallon cans; a truck then picks up the cans and takes them to the dairy. Milk handled in this way is classified as grade B, suitable for cheese production but priced at a lower rate than that for grade A milk. To meet state health guidelines for grade A milk, some Amish farmers use gasoline-powered generators in the barn areas. The use of generators is dependent on the district bishop's ruling and thus not an option in all districts.

The bishop's ruling also applies to the use of other motorized farm machinery. A few bishops allow Amish farmers to use tractors. The guideline is that tractors are not to be used as transportation. They can be used to propel pulleys in the operation of saws, augers, and so on, and in some districts they can be used in the fields. But the bottom line

remains: Amish are not to drive the tractors to town.

The Amish depend on themselves and the community in times of need and crisis. Although they pay into the Social Security system they do not file for it when eligible, and no Amish name appears on the welfare roles. The Amish bishop acts as the secular "English" trustee, determining those in need in his district. Emergencies of ill health, property damage, and the loss of a spouse are brought to the attention of the district's bishop. If a barn or house is destroyed by fire or tornado, neighbors and friends provide supplies and labor to rebuild. Clothing and food is donated to those in need. The Amish and Mennonite relief sales, usually held biannually in each community, help to supplement the relief coffers, and each family is expected to donate an amount, in money or goods, proportionate to its level of prosperity.

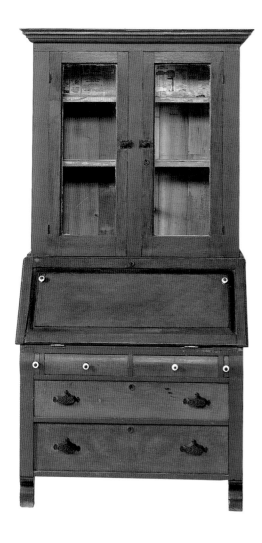

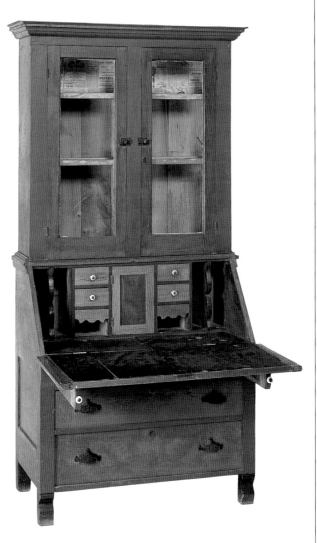

This painted secretary was purchased used at an auction in 1890 by John and Mary Christner. Their daughter, Annie Christner Bontrager, continued to use it until 1990.

This chest of drawers, 1905, was made for Susie Schrock before her marriage to Henry Miller. Susie was one of the most prolific northern Indiana Amish quilters (see page 71).

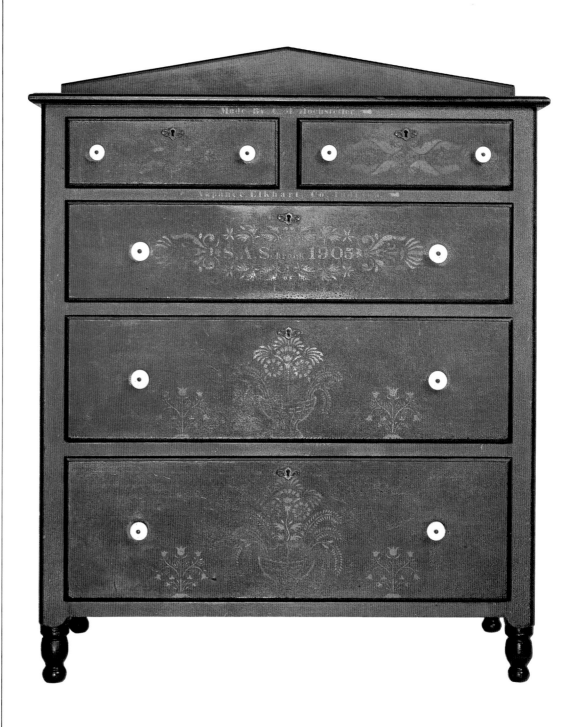

AMISH STYLE

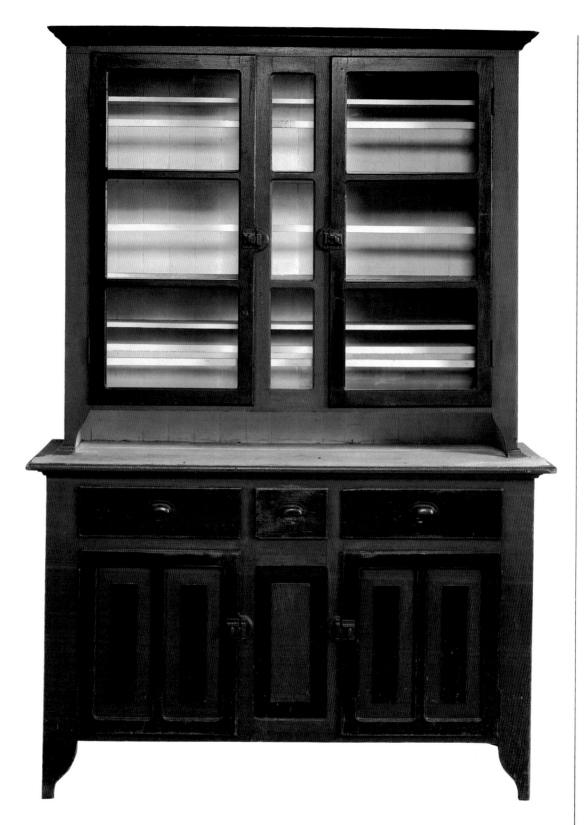

In this kitchen china cabinet, ca. 1900, Mattie Fry not only kept her china but also stored mementos of her life.

Reverse painted and metal foil wall decorations can be found in many Amish homes.

Among the dishes used by Sadie Mast are a child's alphabet bowl, a souvenir Florida plate, and nineteenth-century soft-paste pieces.

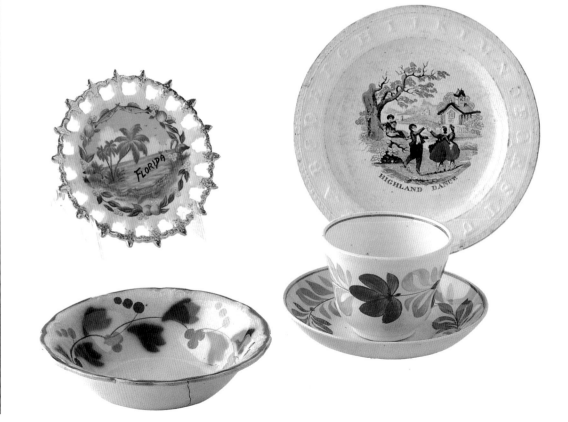

Windows in the Amish house usually have either simple white curtain panels tied back or white curtains across the lower panes with green window shades above.

Auctions are held to disperse belongings when a family moves, an older couple moves into smaller quarters, or the owner of the items dies.

This homemade barn set includes representatives of all the animals found on most Amish farms.

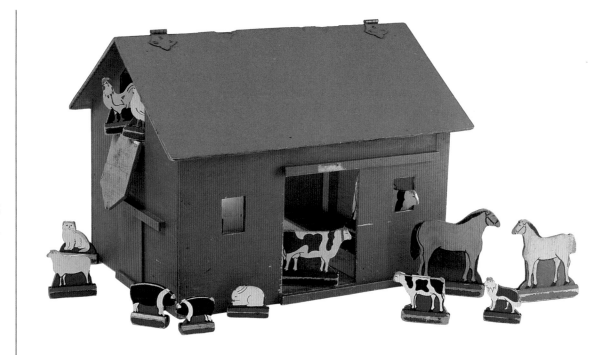

A wooden, painted, hand-carved draft horse depicts the real horses used to farm the land. The primitive blue denim folk piece further illustrates the range of toys found in Amish homes.

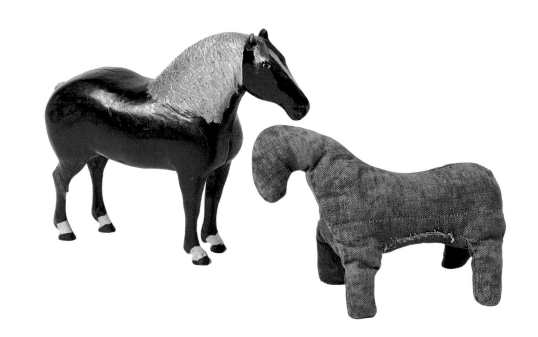

TOYS AND DOLLS

Childhood in an Amish community, as elsewhere, is a time to play and learn. Learning can take place in a structured setting or informally. The toys of Amish children reflect their culture and environment, including Amish religious beliefs. Amish toys would be considered gender-biased by the outside world. Little girls play with little girls' things—that is, dolls—and little boys play with little boys' things—that is, toy horses, wagons, trucks, and tractors.

Cloth dolls are dressed as an Amish adult, from the layers of clothing to the coverings and bonnets.

The main difference between "English" dolls and Amish dolls is the lack of facial features on Amish dolls. The Amish interpret the scriptural passage "Thou shalt not make unto thee any graven image, or any likeness of any thing that is in heaven above" (Exodus 20:4) to include pictures of themselves and facial features on dolls. The boys' toys generally depict the occupation that the majority will pursue as adults—farming or carpentering. Handcrafted barns, barnyard animals, and farm implements are found in most toy boxes.

The Amish speak German in the home, and the children generally do not speak English until they go to school. Their German is a unique dialect, a combination of the German of the sixteenth and seventeenth centuries and English. Children begin school at age six or seven and, in accordance with state law, continue through the eighth grade. If the family can afford the tuition, the children will go to the district's Amish school, usually a one-room school house where all students are seated together and have one teacher. Most teachers in the Amish schools are unmarried Amish women who have completed the eighth grade.

Amish schools teach only basic reading, writing, and arithmetic. The Amish feel that those skills alone are needed—to read the Bible and to keep the farm accounts. Further education is considered worldly knowledge and unnecessary. In the Amish view, there are much more worthwhile things to do, such as tilling the soil and cultivating the gardens. The children's toys reflect that view.

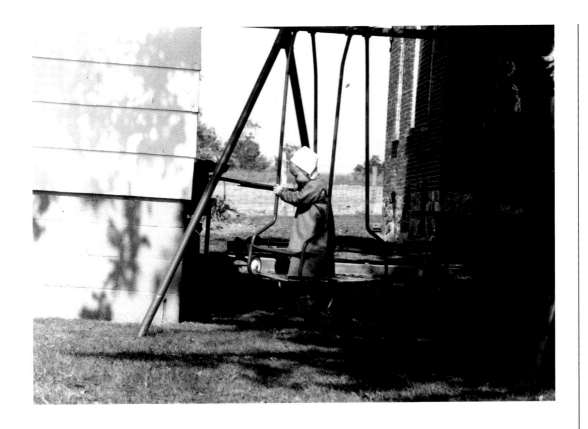

Children from early age wear the prayer cap.

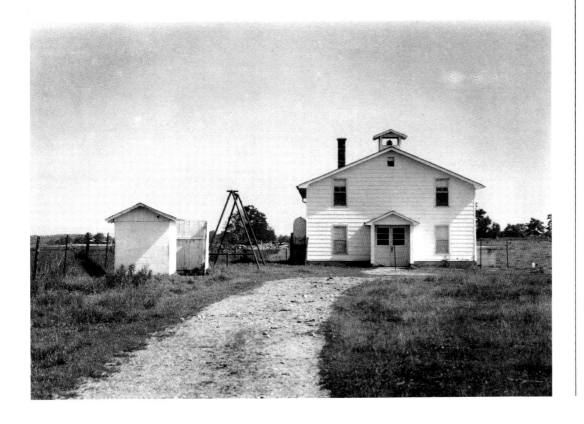

An Amish school house sits idle during the summer break.

Amish dolls, called "lumba bubba" (rag dolls), are faceless in accordance with the Bible verse that forbids "graven images." Sometimes, however, children will add crude facial features.

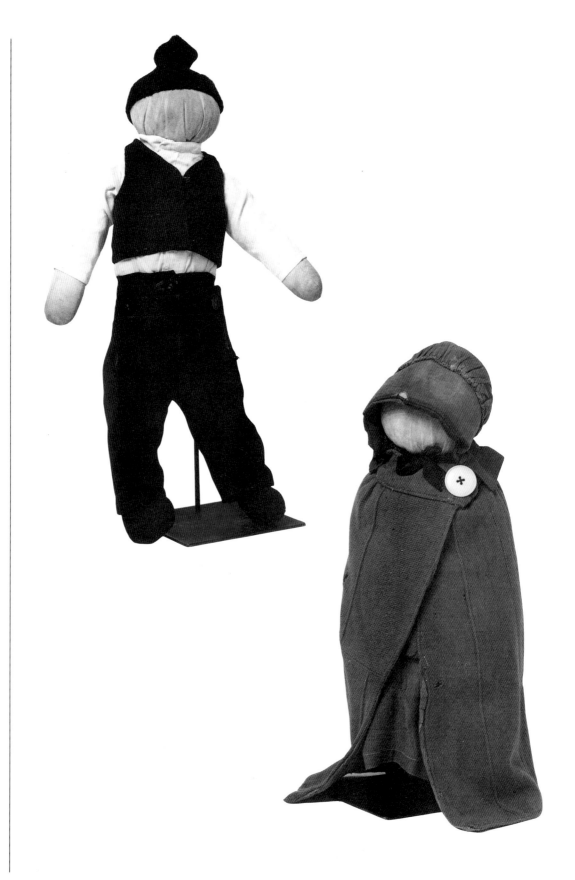

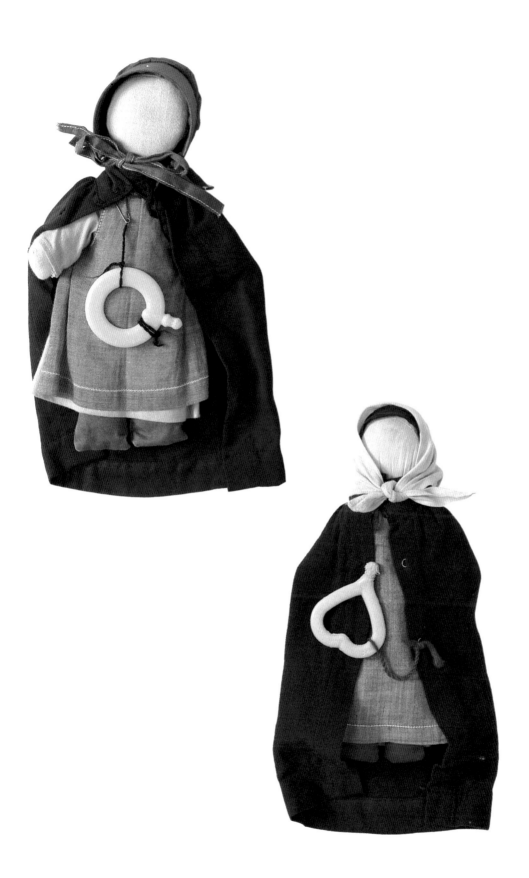

Church dolls, with every clothing detail in accordance with the northern Indiana Amish community's dress regulations, were used to keep young children and infants occupied during the long church services.

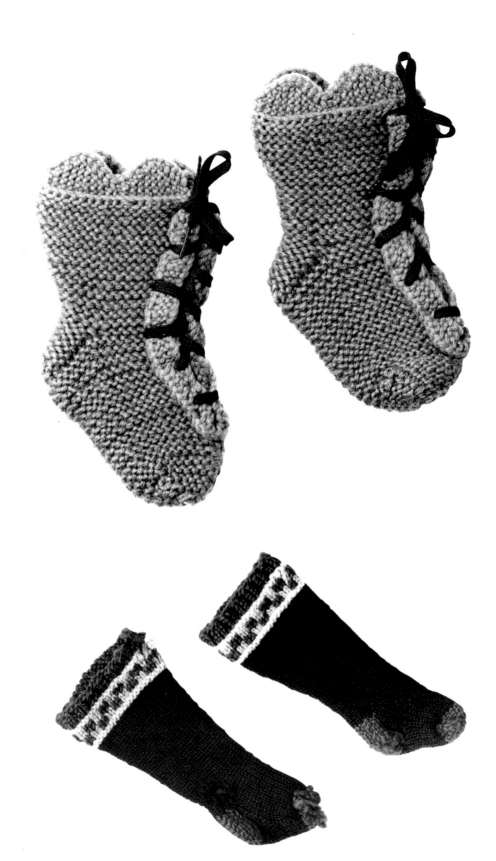

Hand-knit baby booties
and doll stockings.

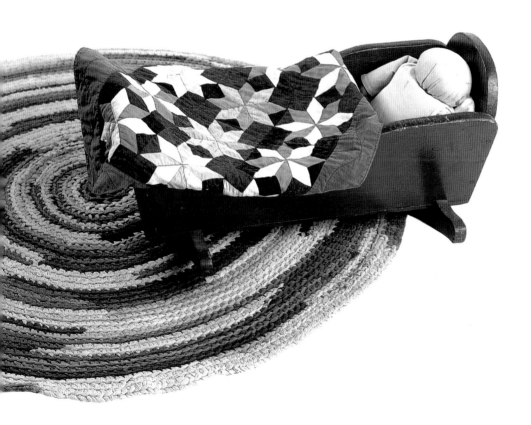

Eight Point Star Doll Quilt

22″ × 19″

Maker unknown

Ca. 1930

LaGrange County, Indiana

The quilt covers a doll
in a painted wooden
doll cradle.

Bear Paw Doll Quilt
16″ × 13″
Maker unknown
Ca. 1925
Emma, Indiana

This doll quilt was made
for Anna Lambert.

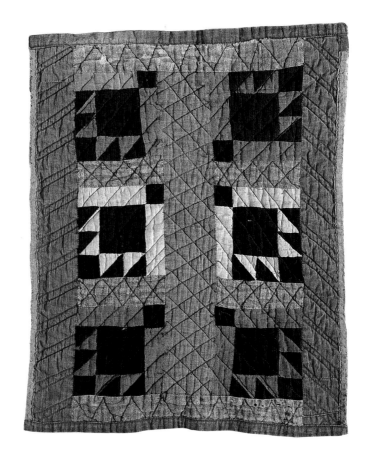

Wedding Ring Doll Quilt
22″ × 19″
Katie Hochstetler and
Ida Eash
Ca. 1945
Honeyville, Indiana

Ida made Katie and her
husband, Dan, a full
Wedding Ring quilt for
their wedding (see page
81). Katie used this extra
block to make a doll quilt
for her first daughter, Ida
Ann, born July 25, 1942.

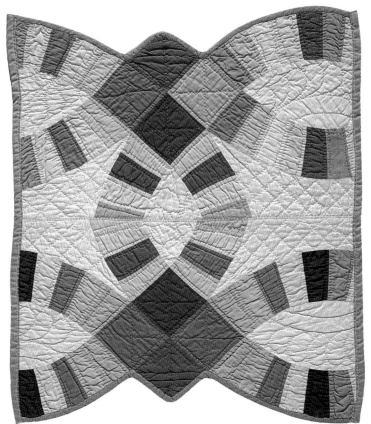

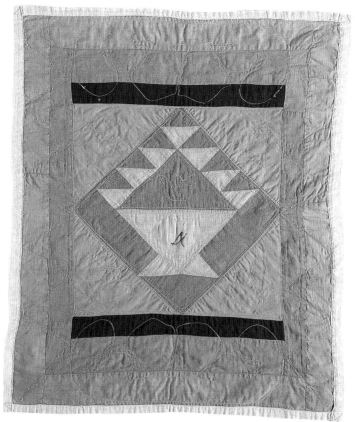

Basket Doll Quilt
21″ × 18″
Mrs. Andy Nissley
1960
LaGrange, Indiana

Mrs. Nissley made this quilt for her daughter, Katie.

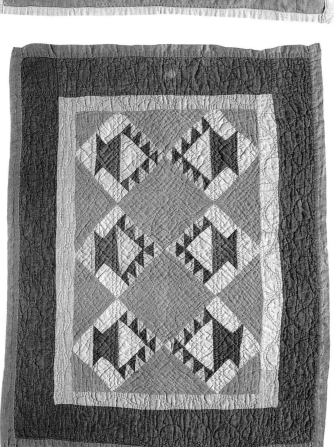

Basket Star Doll Quilt
27″ × 21″
Mattie Chupp
Ca. 1920
Goshen, Indiana

Mattie made this doll quilt for her granddaughter, Mattie Mast, who at the time lived in Kalona, Iowa.

Birds in Flight Doll Quilt
17″ × 17″
Mary Hochstetler
Ca. 1928
Millersburg, Indiana

This doll quilt was pieced
by Mary and quilted by
her oldest daughter,
Katie, born February 25,
1922. It is probably
one of Katie's first
quilting attempts.

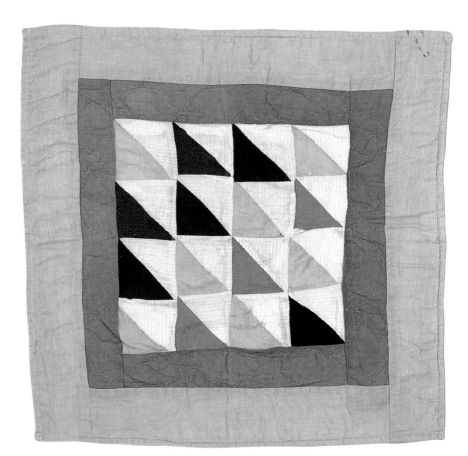

Diamond in Square
Doll Quilt
17″ × 16″
Mattie Hochstetler
Ca. 1960
Middlebury, Indiana

Mattie made this doll
quilt for her
granddaughter.

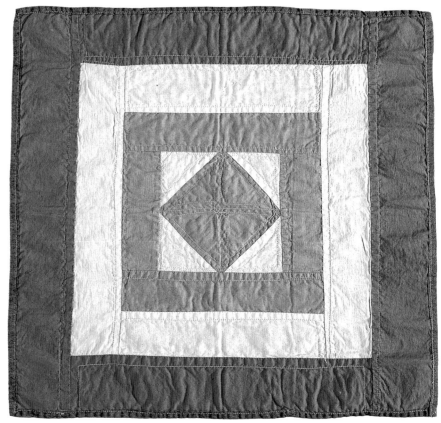

AMISH STYLE

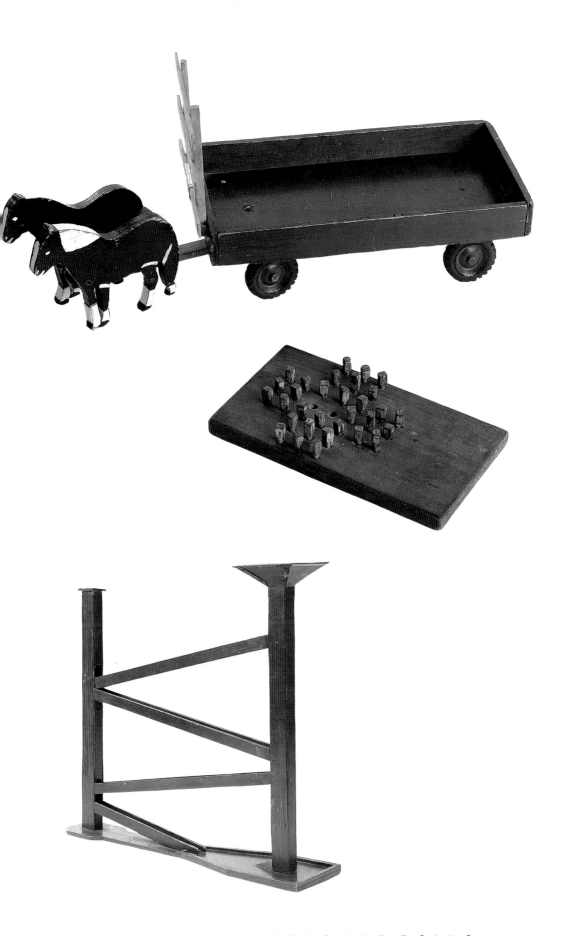

Typical toys for Amish
children are these painted
wooden horses and hay
wagon and painted
wooden peg game.

Painted marble chase
game, ca. 1920

Nine Patch Crib Quilt
48″ × 33″
Suzanne Schmucker
Ca. 1870
Nappanee, Indiana

Suzanne, born 1844,
used this quilt for her
children between 1877
and 1892. The quilt was
passed down to her
granddaughter, who lives
in Wisconsin.

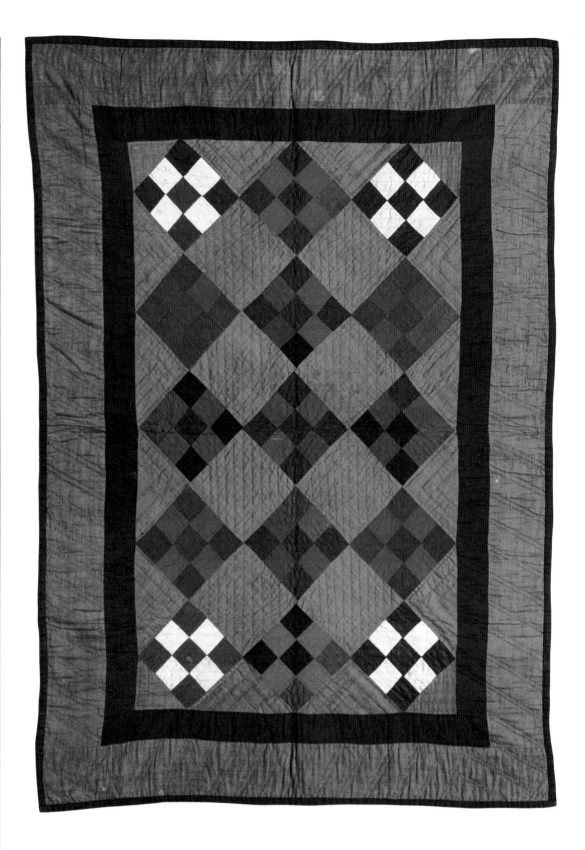

QUILTS

Quilts seem to have been generally exempt from the religious prohibitions against other forms of the decorative impulse. The utilitarian nature of quilts had a great deal to do with their acceptability, although there were limits, such as strictures against the use of printed fabrics. Some historians theorize that the quilts were the sunshine in the otherwise grim Amish culture, and it is true that the craft is one of the few creative activities allowed the women. When we consider that the color black signifies joy to the Amish, however, that explanation certainly

needs to be reviewed more closely. Some researchers note the inability of the Amish to articulate the sources of their designs and quilt traditions, suggesting an innate proclivity. The recurring repertoire of patterns perhaps should lead us to consider instead both the practice of sharing patterns among family and community members and the wide participation in the social aspects of quilting. At the same time, the important artistic outlet that quilting provided for the women cannot be denied.

Observers continue to speculate that the basic pattern names—Honeycomb, Diamond, and Cross within a Cross, for example—are directly linked to fundamental aspects of Amish belief: natural fertility, bearing the cross of faith, revelation of the chosen, and righteousness. It must be noted, however, that the quilting traditions in the "English" communities of the same periods also used the same patterns, although in different color combinations. Perhaps the Amish were influenced more strongly by the outside world than has been believed.

Examples of Indiana Amish quilts have a greater amount of pieced work than those produced in Pennsylvania. Fabric scraps are stitched into pattern blocks, which are in turn sewn together in strips and quilted to the larger backing material, with a batting in between. Complicated appliqué patterns are also used. Indiana Amish quilts, thought to be a little more influenced by outside traditions of the craft, employ patterns and devices common to "English" quilts. Until the l930s a black or very dark background was common, although the pieced col-

ors seem brighter and more playful than those of Lancaster County, Pennsylvania, quilts of the same period. Eastern severe plainness was replaced by greater invention and asymmetry in the midwestern pieces.

The introduction of the sewing machine in the 1850s provided a faster means to produce clothing and bedding. Treadle sewing machines are found in all Amish homes, usually placed under a window for light. The piecing of most quilts is accomplished on the machine. The quilting is then done by hand.

As the Amish continue to live in consolidated communities and endeavor to be self-reliant within the community, more and more men, for economic reasons, are forced to leave the farm and seek outside employment. The women are also finding ways to supplement the family income. Selling quilts is one means to earn money while staying at home. One consequence of this cottage industry is the adverse impact on the Amish quilt itself.

In the past, Amish quilts were made to fulfill one basic need, warmth. As the emphasis shifts increasingly to a commercial product, the dark, simple, vibrant designs that had been passed from mother to daughter are being replaced with pastels and prints. The Amish women appear to have lost that special sense of color and design which made the Indiana quilts unique.

Sewing Stand
14″ ht. × 8.5″ diam.
Maker unknown
Ca. 1890
Honeyville, Indiana

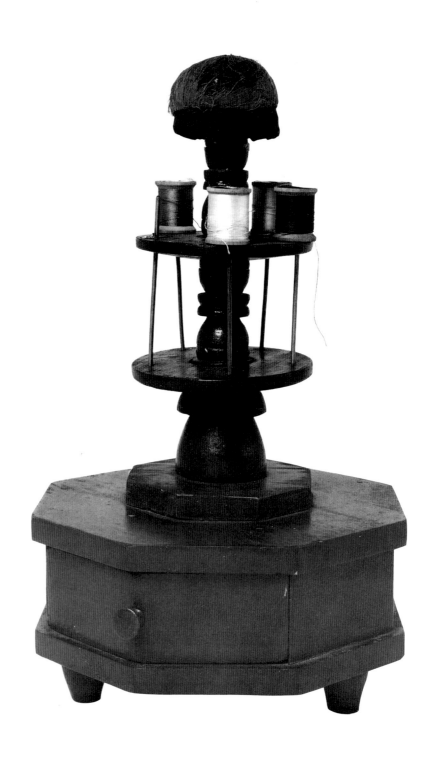

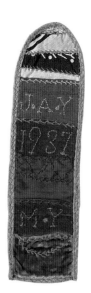

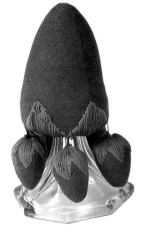

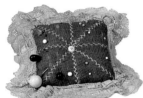

Sewing tools: needle
cases; dated and initialed
strawberry pincushion,
mounted on an
oil lamp base, and
an embroidered and
lace-ruffled pincushion;
quilt piece templates.

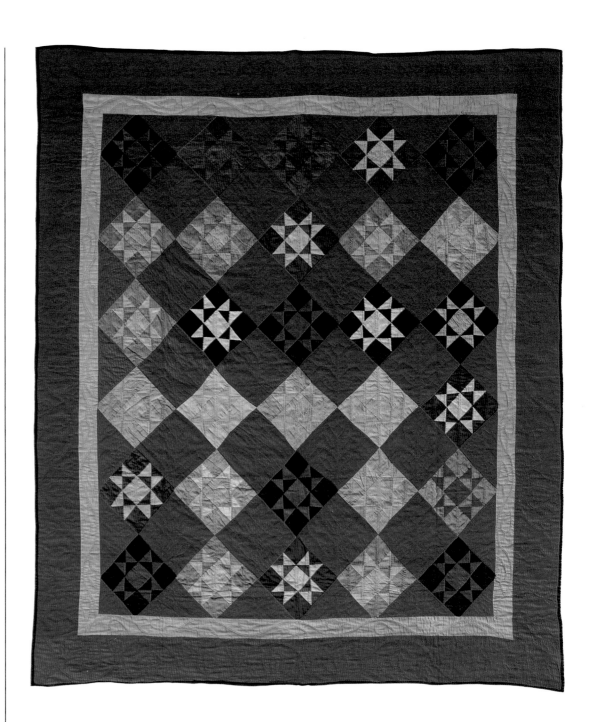

Ohio Star
79″ × 66″
Mattie Bontrager
Ca. 1915
Topeka, Indiana

Mattie made this striking
quilt for her oldest
daughter, Fannie, born
October 28, 1896.

—— A M I S H S T Y L E

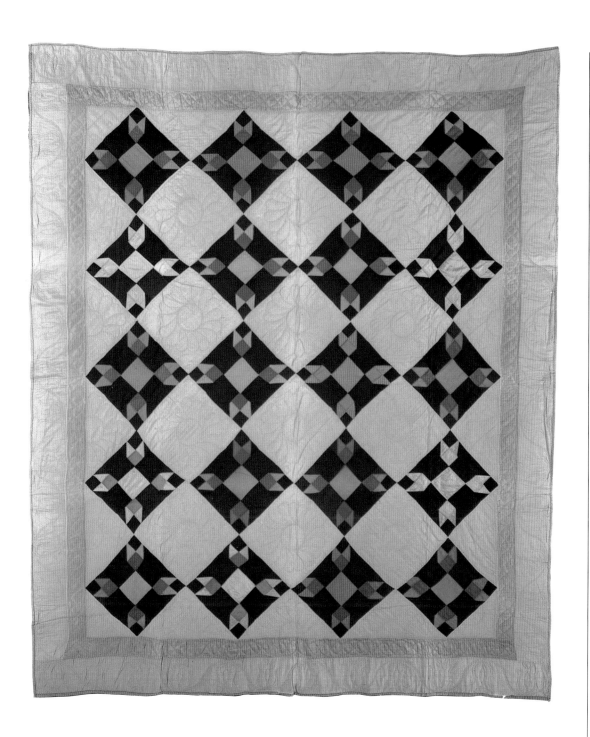

Goosefoot

82″ × 66″

Mattie Bontrager

1914

Topeka, Indiana

Mattie made this quilt for her oldest daughter, Fannie. The quilt is signed and dated "F. B., 1914." Three other quilts shown here (pages 68, 69, and 99) were all made from quilt piece templates shared within the family.

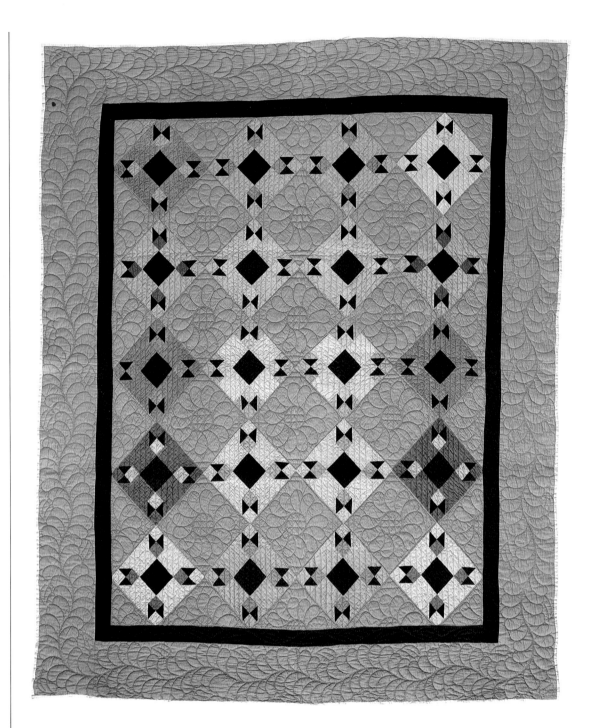

Goosefoot
87" × 71"
Amanda J. Bontrager
Ca. 1920
Topeka, Indiana

Amanda, her sister
Fannie, and her mother,
Mattie Bontrager, each
used this pattern to
make quilts.

AMISH STYLE

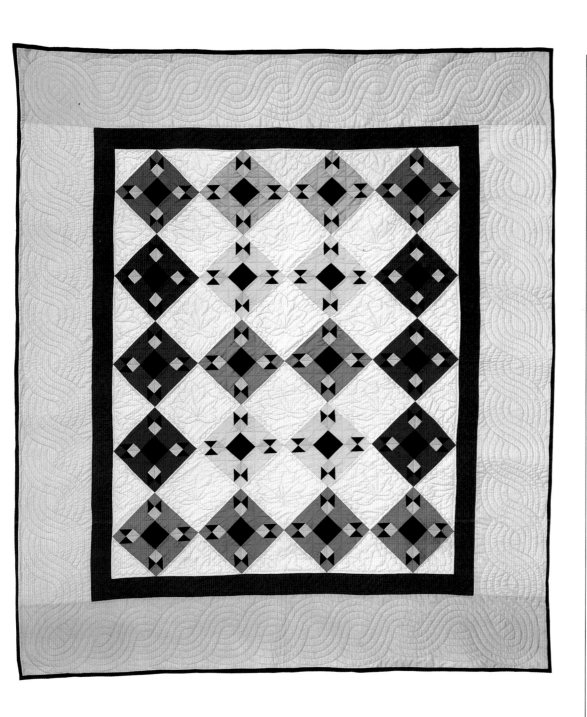

Goosefoot

99″ × 87″

Amanda Yoder Schmucker

1985

Topeka, Indiana

Amanda's mother,
Amanda Bontrager Yoder,
her aunt, Fannie
Bontrager Gingerich, and
her grandmother, Mattie
Bontrager, have each
used the same templates
to make quilts since
1914. Notice that the
color and materials of
this quilt differ greatly
from those of the earlier
family pieces (see pages
67, 68, and 99).

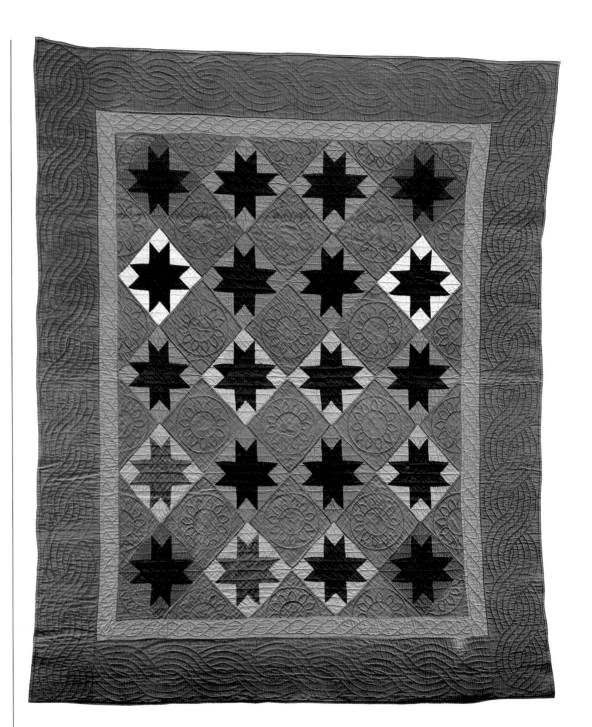

Variable Star
84″ × 67″
Katie Troyer Miller
Ca. 1915
LaGrange County, Indiana

Katie made this quilt after
her marriage to John A.
Miller on March 30, 1915.

AMISH STYLE

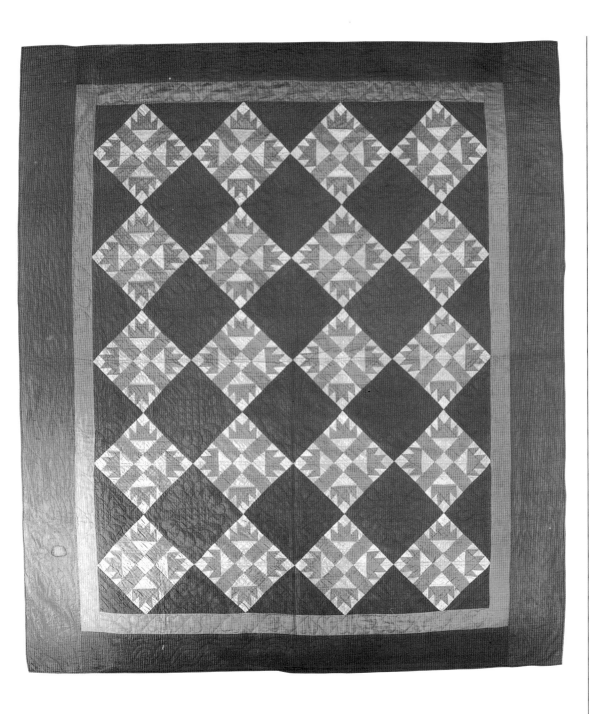

Bear Paw Cross
79″ × 70″
Susie Schrock Miller
1932
Topeka, Indiana

Susie, born December 13, 1888, married Henry Miller on February 6, 1908. They had eight children: Annie V., Lydia Mae, Verna E., Ammon H., Beulah M., Ervin H., Wilma M., and Verlo H. All but two of the children remained in the Old Order Amish church. Susie continued quilting until near age ninety.

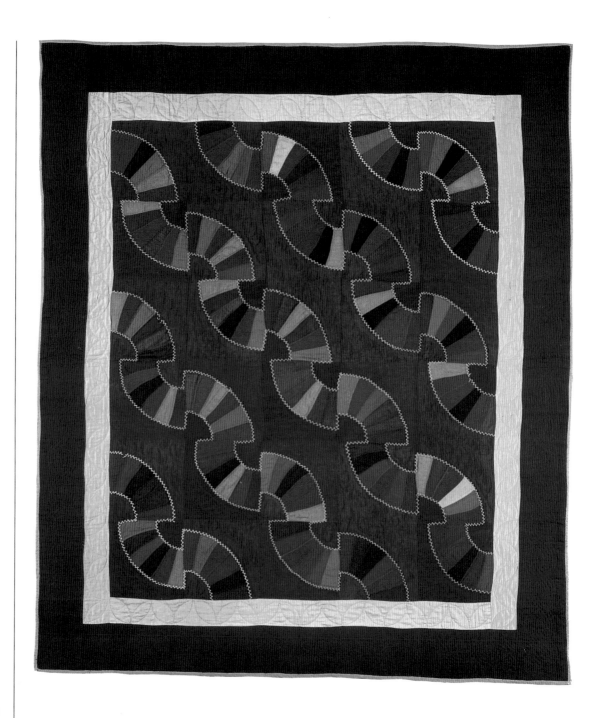

Fans
85″ × 72″
Mary Hershberger
Ca. 1935
Topeka, Indiana

AMISH STYLE

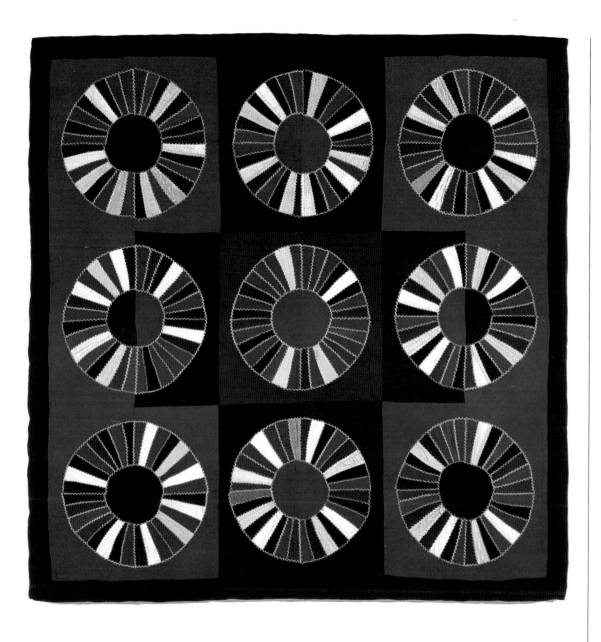

Fans Variation
72" × 71"
Clara Hershberger
1912
Nappanee, Indiana

Before Clara married
Andrew Helmuth, she
borrowed a wedding ring
and took a train trip to
Chicago. Clara and
her daughters were
all quilters.

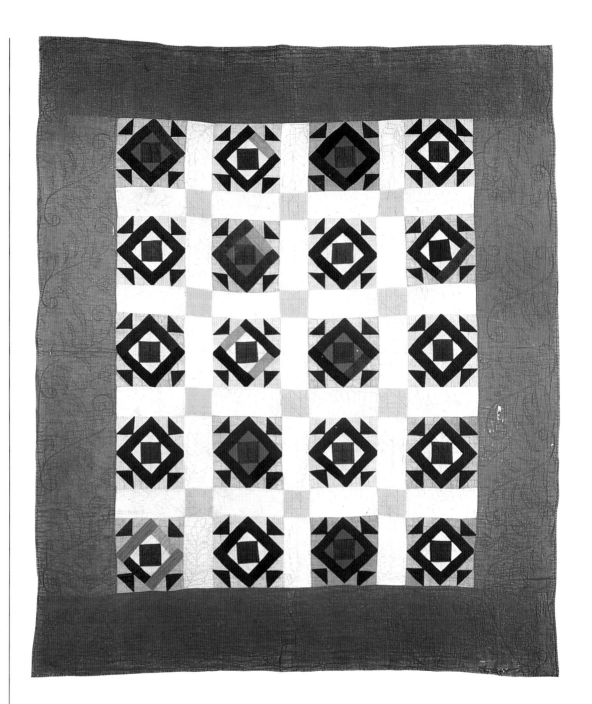

Shoe-Fly with
Central Diamond
87″ × 72″
Grandmother of
Abe A. Yoder
Ca. 1880
Honeyville, Indiana

Signed "Amos Yoder,"
this quilt is believed to
have been made for Abe's
father by Amos's mother.
Abe, born May 1904, was
bishop of District 32.

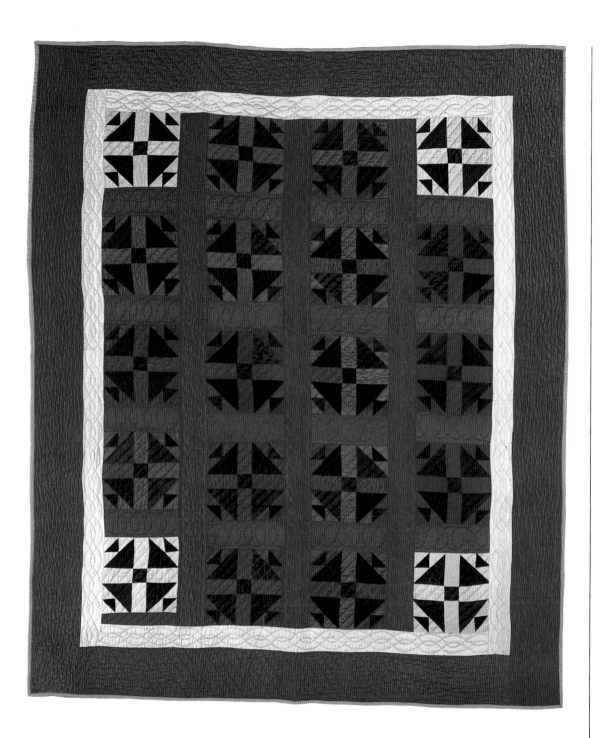

Goose Chase Variation

87″ × 72″

Sarah Bontrager

Ca. 1940

LaGrange, Indiana

Sarah, born February 2,
1920, married Erwin Mast
on December 5, 1951.
They had no children.

Rabbits Paw
85″ × 71″
Sarah Bontrager
Ca. 1940
LaGrange, Indiana

Many unfounded myths surround the Amish quilts. It has been said that the Amish intentionally work an error into each of their quilts, so that none is perfect, thus reflecting the belief that only God can create perfection. David Pottinger asked Sarah about the one block that was set differently in this quilt. She looked at the block, smiled, and said she had never noticed it before. Again, no evidence was found to support the intentional-error theory. Sarah's other quilts (see, for example, page 75), also show a certain naïveté in her construction technique.

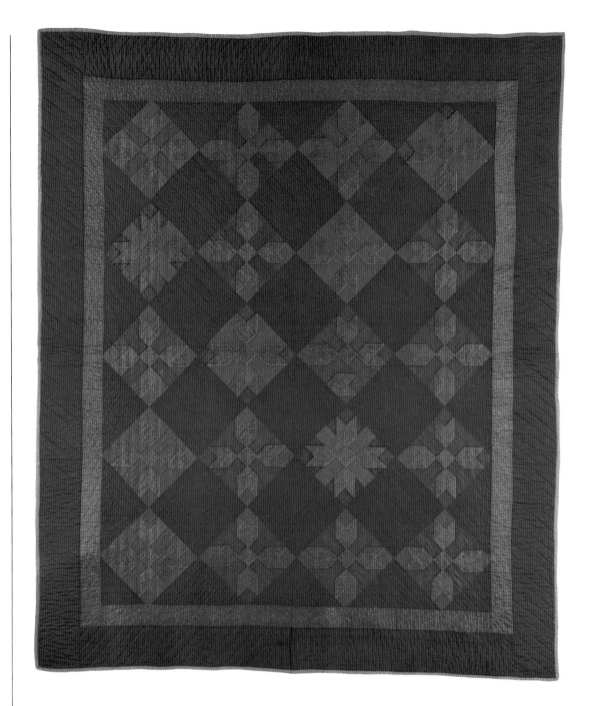

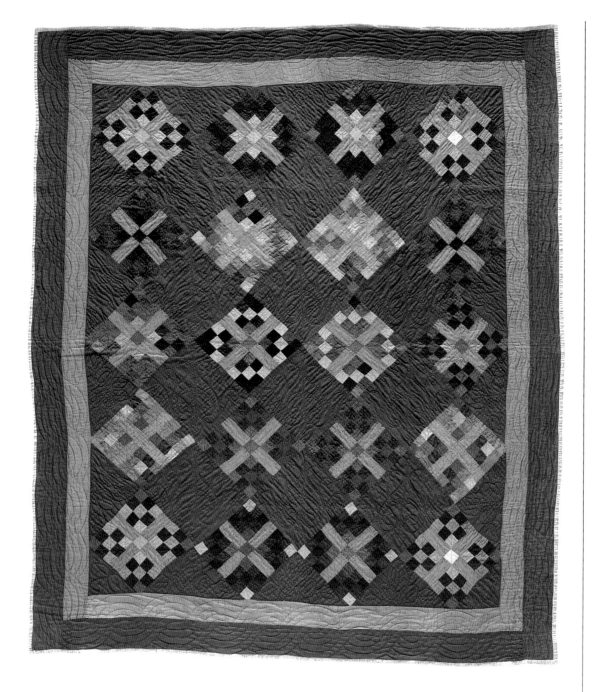

Nine Patch Cross

81" × 70"

Barbara Hochstetler

1903

Emma, Indiana

Signed and dated
"M. O. H., 1903," this
quilt was made for Mattie
Hochstetler Bontrager,
who lived on the Old Milt
Lambright place.

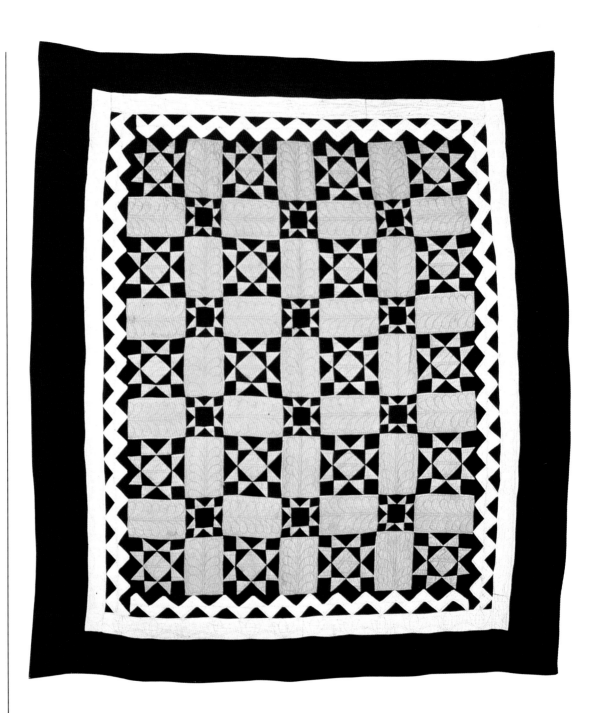

Eight Point Star
78″ × 68″
Fannie Yoder Lambright
Ca. 1936
Emma, Indiana

Fannie made this quilt for
her daughter, Elsie, born
1915. Elsie remembers
her mother piecing the
quilt and then letting
Elsie help quilt it.

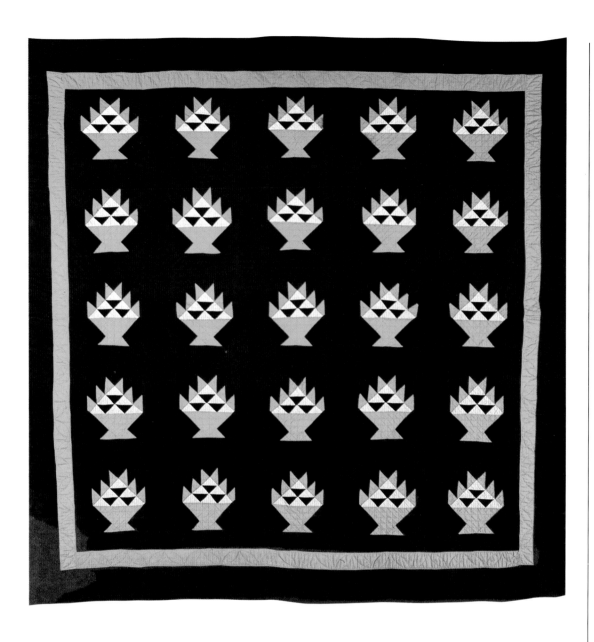

Baskets

76" × 76"

Fannie Yoder Lambright

Ca. 1936

Emma, Indiana

Fannie made this quilt for her daughter, Elsie, before Elsie's marriage to Eli Miller in 1940.

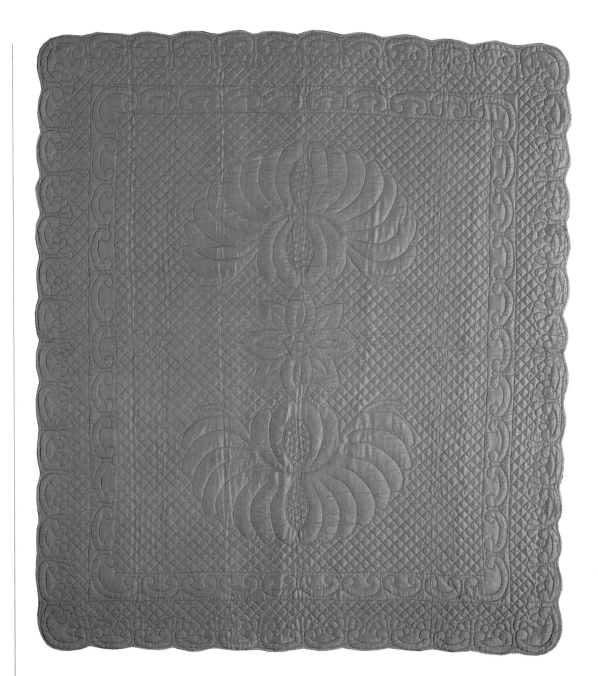

Plain Quilt
83″ × 74″
Anna Christner Miller
Ca. 1932
Topeka, Indiana

This wholecloth quilt was
made for Anna's
daughter, Sylvia, prior to
Sylvia's marriage to
Jonas Hostetler. Although
wholecloth quilts are
not common in the
northern Indiana Amish
community, Sylvia made
an identical quilt
one year later.

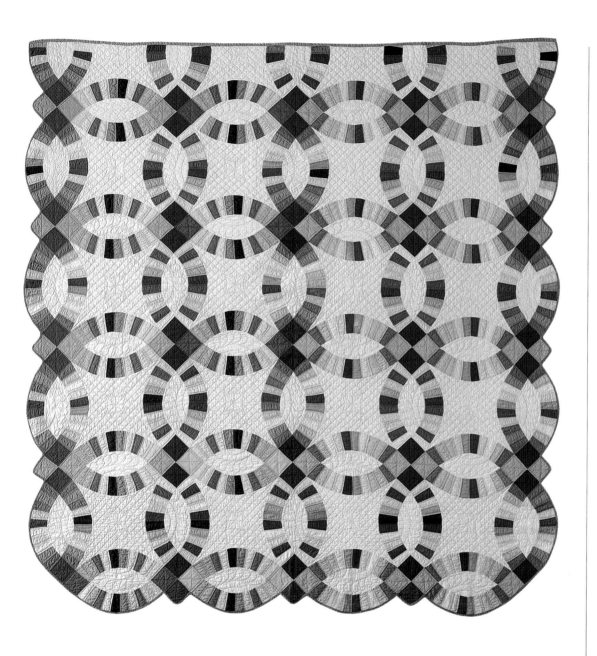

Double Wedding Ring
81″ × 79″
Ida Beachy Eash
Ca. 1940
Honeyville, Indiana

Ida made this quilt for
her daughter Katie's
marriage to Dan
Hochstetler on
February 13, 1941.

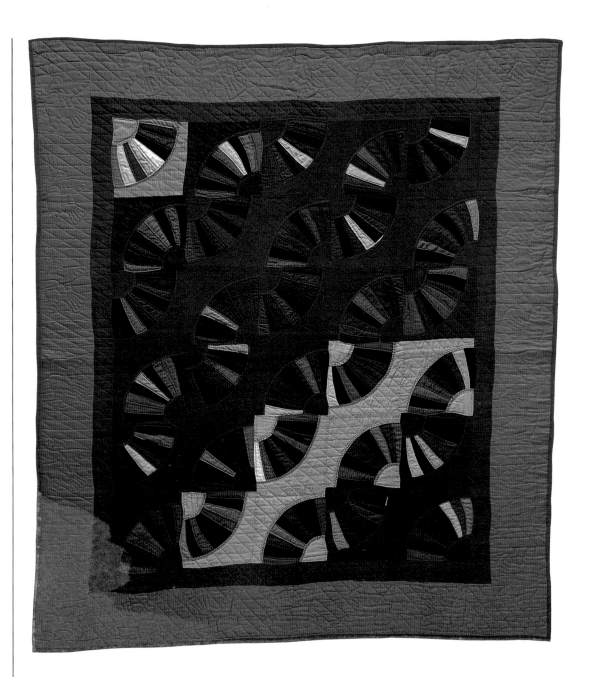

Fans
86″ × 73″
Maker unknown
Ca. 1910
Middlebury, Indiana

Believed to have been
made by Ida Miller's
grandmother, this quilt
was passed down in the
family until Ida's death
in 1985.

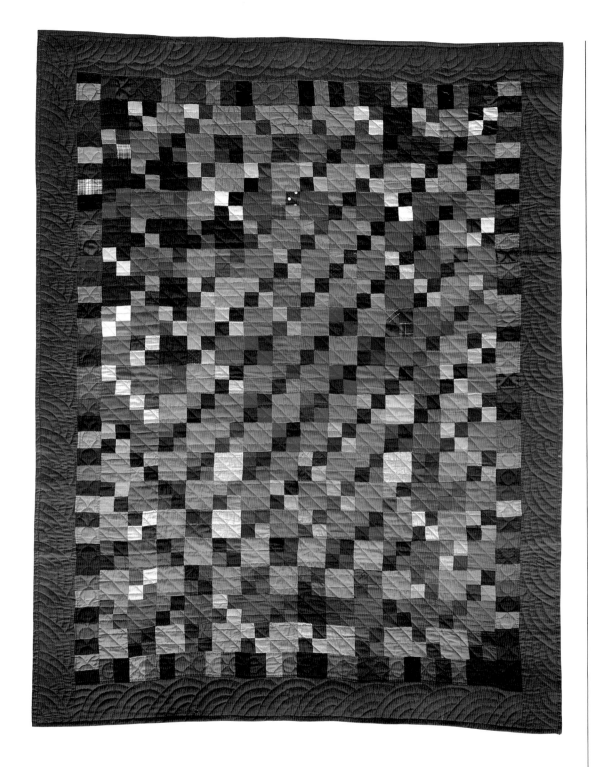

Four Patch with
Chinese Coin Border
78″ × 62″
Anna Mishler Troyer
1887
Middlebury, Indiana

Anna made this quilt for
her daughter, Anna, at
the time of her marriage
to Joseph D. Kauffman in
1887. At Anna Kauffman's
death in 1948, the quilt
was given to her
daughter, Katie
Riegsecker, when the
household belongings
were distributed among
the children and
grandchildren. The quilt
was later passed down to
Katie's daughter, Mary.

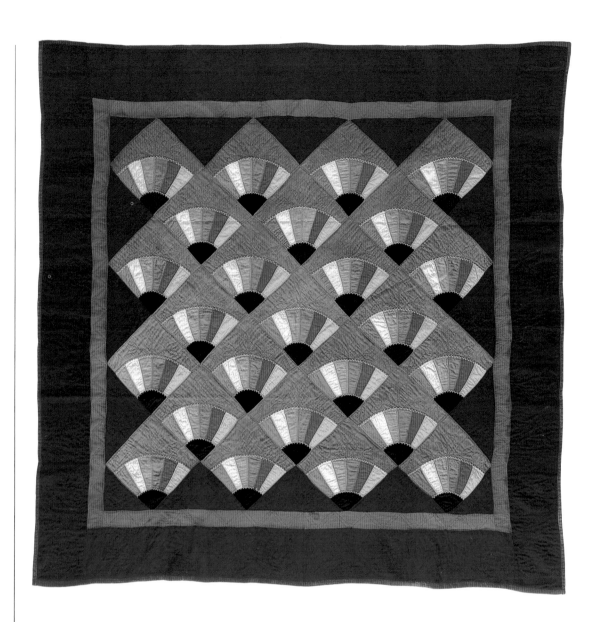

Fan Variation
77" × 74"
Annie C. Hochstetler Lohman
1915
LaGrange County, Indiana

Annie worked very hard to complete this quilt for her wedding on January 28, 1915. The quilt is signed and dated "A. H., age 18, Jan. 8, 1915." Annie made three similar quilts for her sisters and then in 1963 made another one for herself.

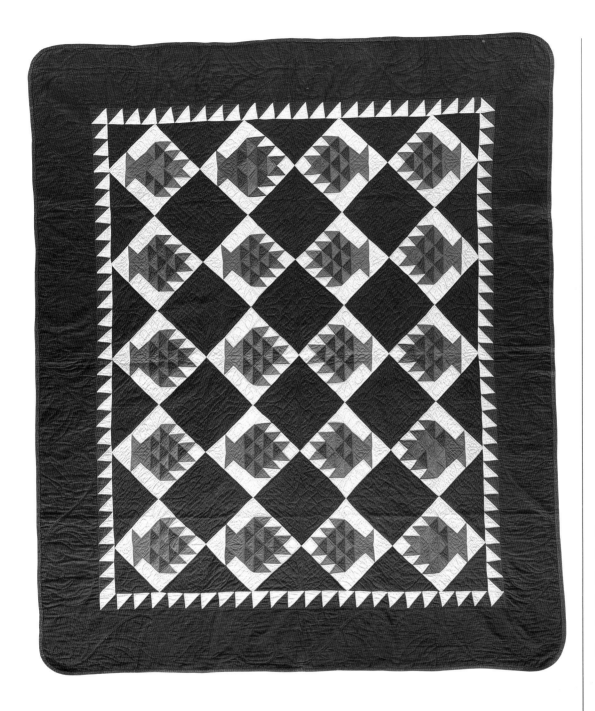

Baskets with
Sawtooth Border
81″ × 68″
Barbara Bontrager Miller
1880
LaGrange County, Indiana

Barbara made this quilt,
dated ''1880,'' for her
son, John, who married
Sarah Schrock on
December 23, 1883.

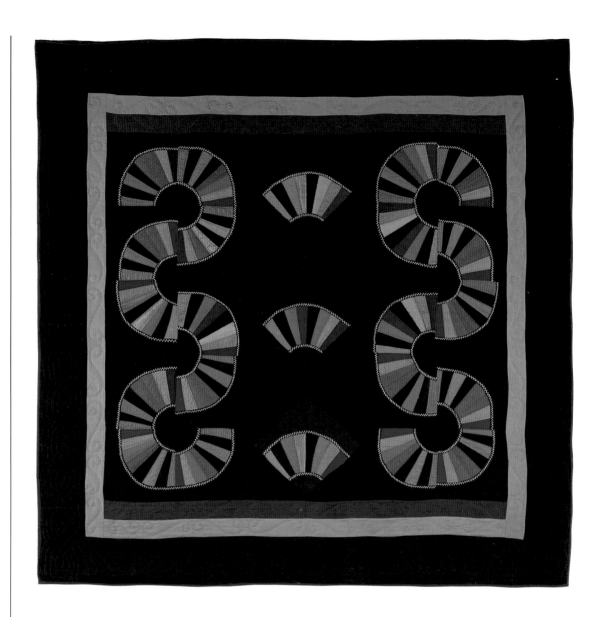

Fans
67" × 66"
Pieced by
Susan Christner
Quilted by
Lydia Ann Christner
1930
Topeka, Indiana

This quilt was made for
Lydia Ann's son, Uriah,
born September 16, 1915.

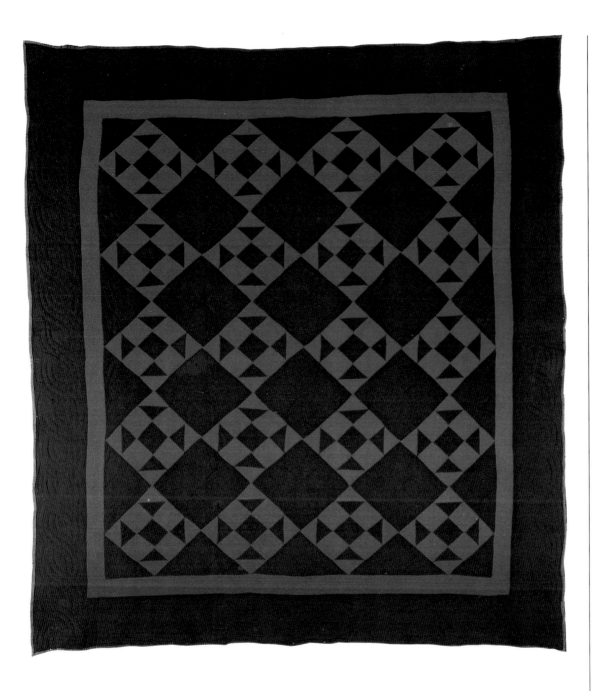

Shoofly

79″ × 71″

Elizabeth Yoder Bontrager

Ca. 1905

LaGrange, Indiana

Made for Abraham
Bontrager, Elizabeth's
son, this quilt was
passed down to Amelia
Miller, Elizabeth's
granddaughter.

Botch Handle
77" × 64"
Susie Christner Yoder
1939
Topeka, Indiana

Susie's first husband,
Aba Bontrager, died in
October 1918, leaving her
with four children. Menno
Yoder's wife, Emma, died
in April 1928, leaving him
with seven children.
Menno and Susie were
married on December 12,
1929. Susie made this
quilt for her son, Harley
Bontrager, born May 5,
1915. The quilt is
signed and dated
"H. B., April 27, 1939."

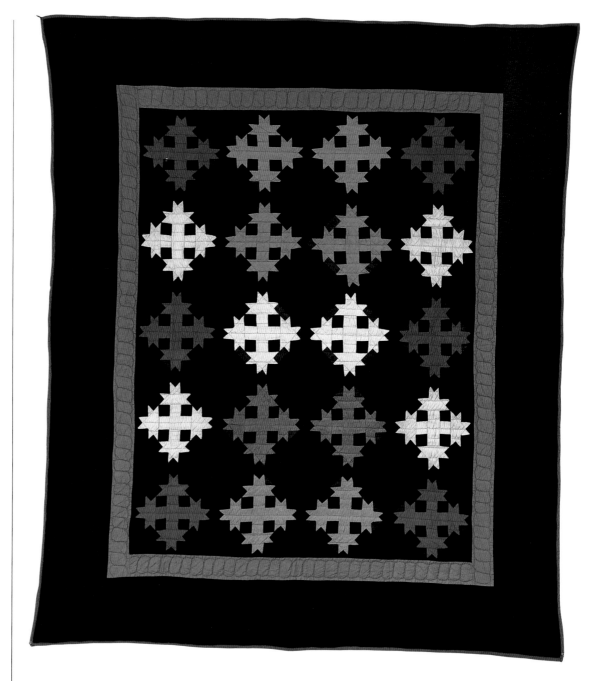

AMISH STYLE

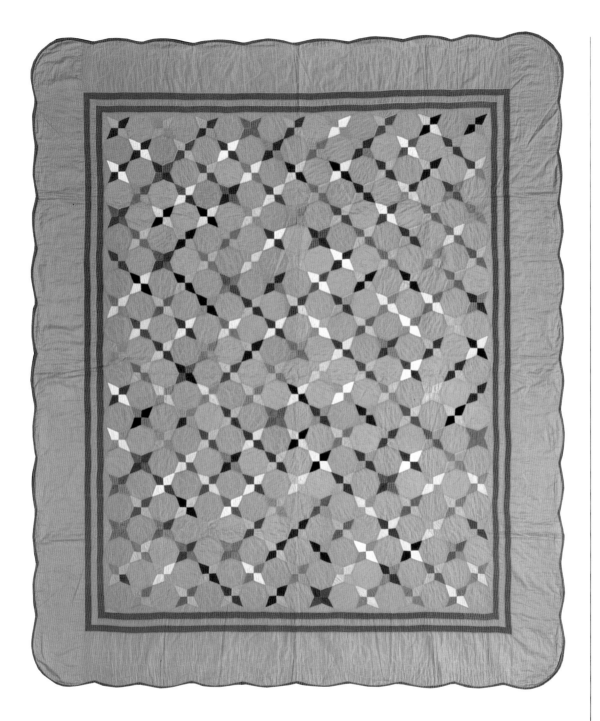

Hummingbird
92″ × 78″
Susie Schrock Miller
1945
Topeka, Indiana

Susie made this quilt for
her daughter, Wilma
Mable, before Mable's
marriage to Amos
Bontrager on
February 15, 1945.

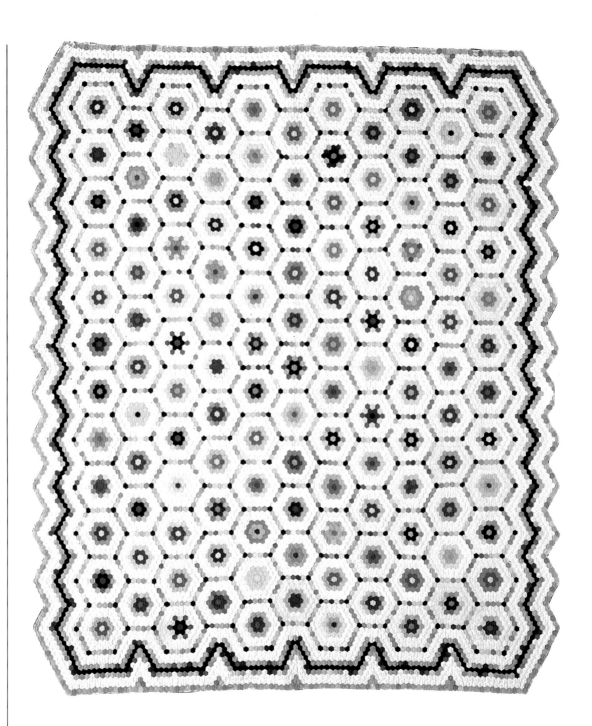

Flower Garden
93" × 78"
Fannie Hochstetler
Ca. 1940
Nappanee, Indiana

Pieced by hand, this quilt
with one-inch-diameter
hexagons never had the
binding applied.

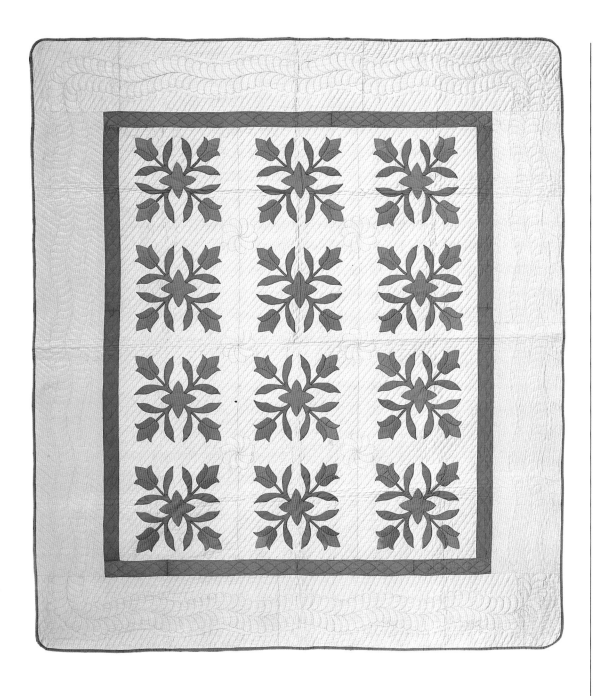

Tulip Appliqué
86" × 76"
Lizzie Hochstetler
Ca. 1932
Nappanee, Indiana

Lizzie, born March 8, 1922, made a number of quilts while still living at home with her mother, Sarah Borkholder Hochstetler. Appliqué quilts are not common among the northern Indiana Amish. Lizzie indicated that her mother had been a little more liberal than some and had allowed Lizzie and her sister to try different things, including the appliqué technique in quilting. After her marriage to Louis Harshberger on November 22, 1936, Lizzie left the Old Order Amish church and joined the Beachy Amish church.

Starburst
86″ × 86″
Anna Chupp Miller
1930
Goshen, Indiana

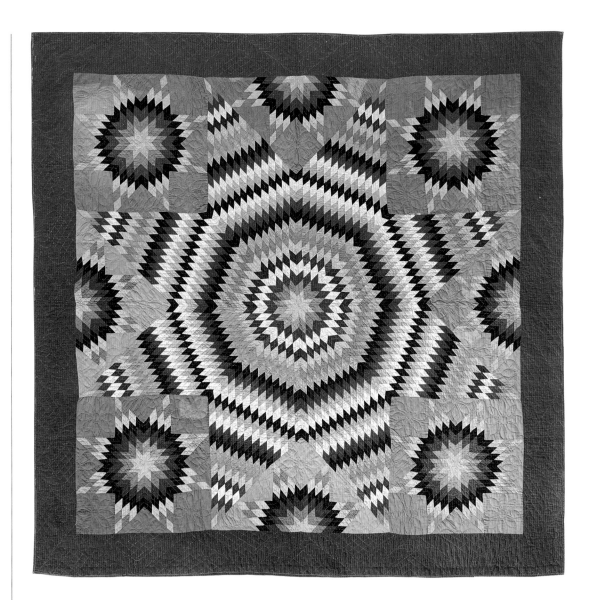

Anna made this quilt for her son, Menno J. Miller, born June 11, 1909, for his marriage to Barbara Miller. Menno and Barbara had nine children. They left the Old Order Amish church and joined the Beachy Amish church.

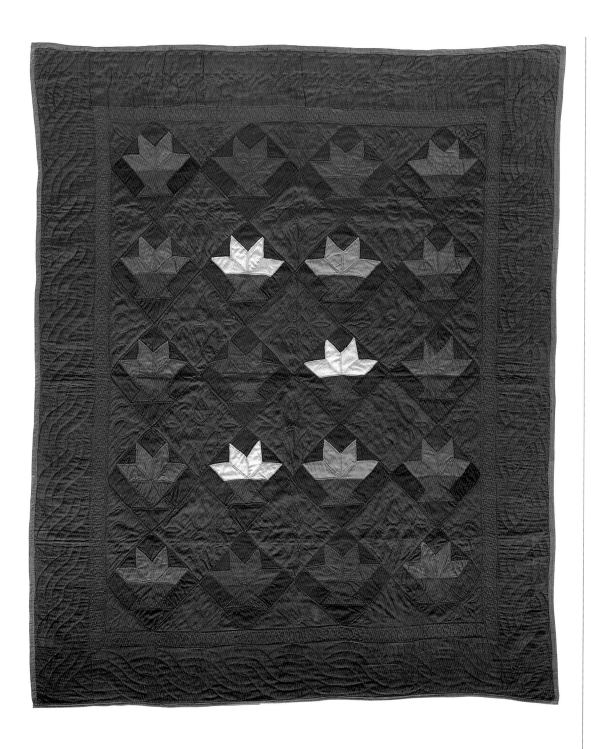

Baskets
78″ × 64″
Annie E. Bontrager
1895
Honeyville, Indiana

Annie made this quilt for her daughter, Lizzie, on her seventeenth birthday, when she joined the church. Lizzie later married Sam Kauffman and lived near Goshen. When Lizzie died, the quilt was given to her nephew. The quilt is signed and dated "Lizzie Bontrager, Feb. 7, 1895."

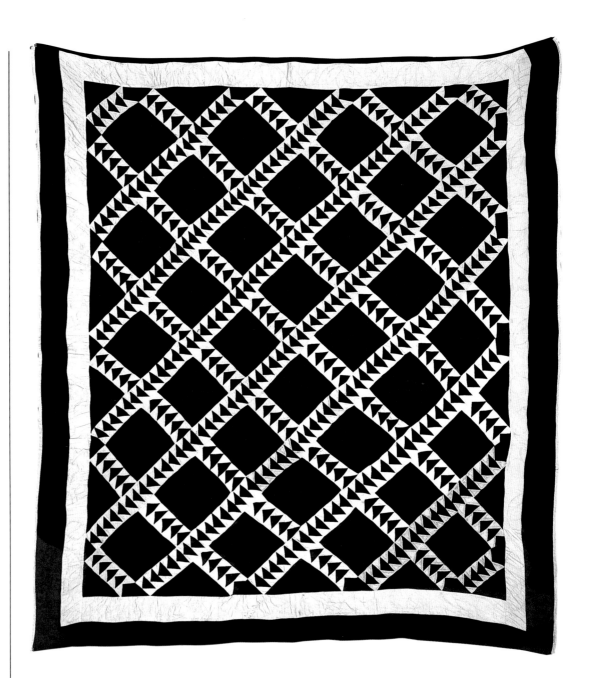

Flying Geese
85″ × 76″
Gertie Miller
Ca. 1920
Yoder, Kansas

Gertie made this quilt for
her son, Samuel, before
he moved to Goshen,
Indiana. Samuel left the
Amish church
about 1930.

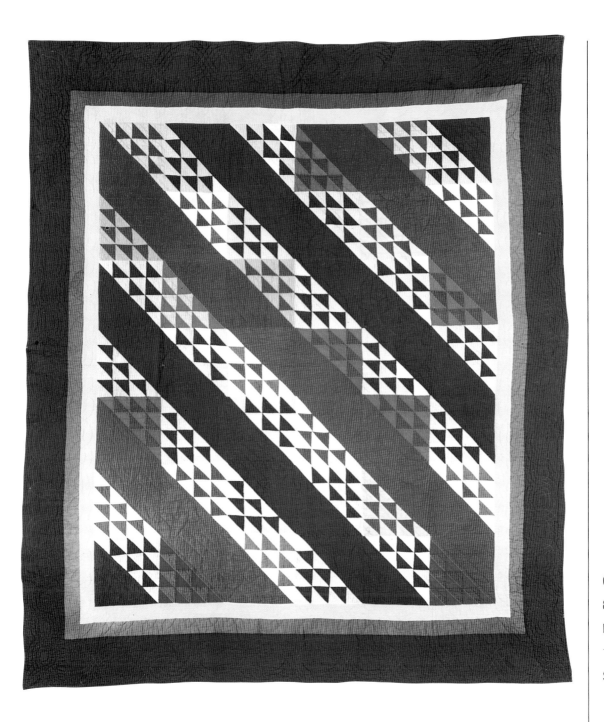

Ocean Wave Variation

83″ × 70″

Maker unknown

1940

Shipshewana, Indiana

When fire destroyed
Ammon Yoder's house in
1940, a neighbor made
this quilt as a gift.

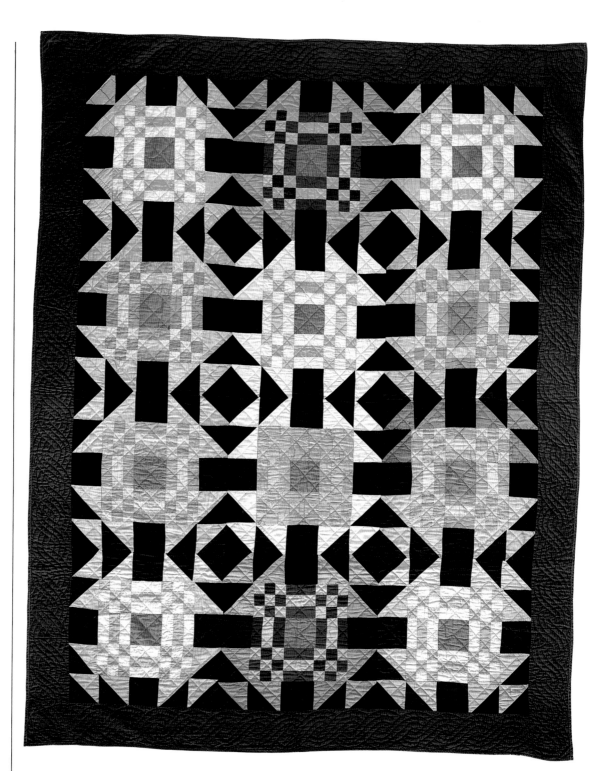

Goose in the Pond
88″ × 69″
Lydia Schrock Yoder
Ca. 1920
LaGrange County, Indiana

Lydia moved to Kansas
after her marriage.

AMISH STYLE

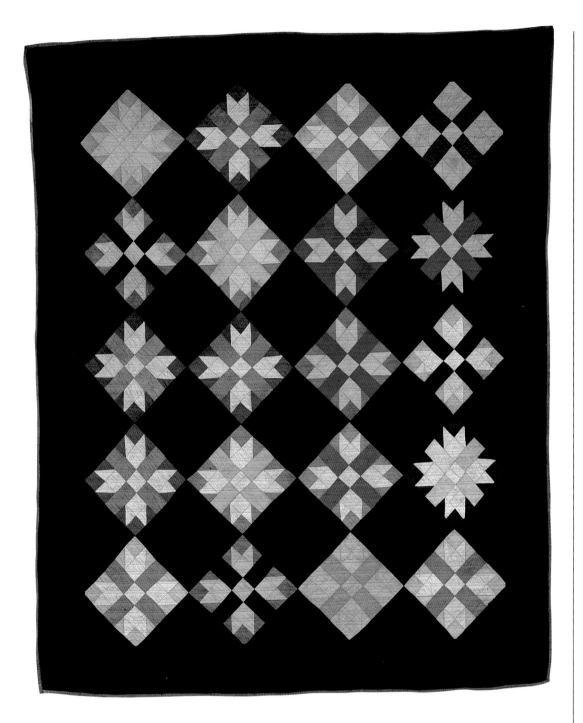

Unknown Design

85″ × 68″

Maker unknown

Ca. 1910

LaGrange County, Indiana

This quilt was made for
Martin Schrock before his
move to Arthur, Illinois.

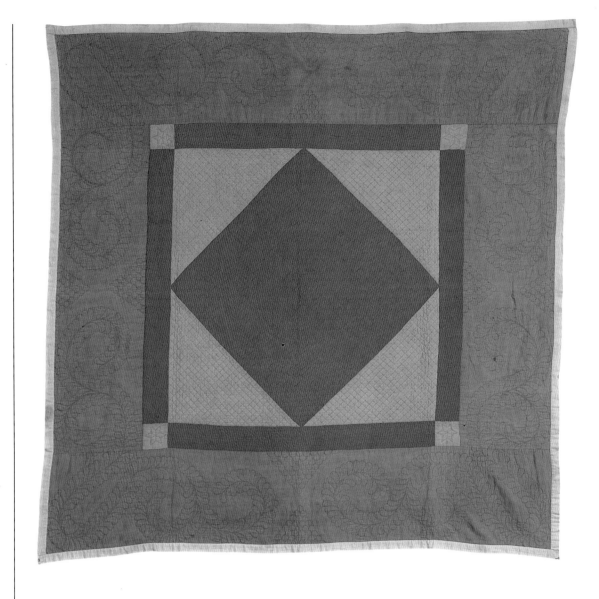

Block and Diamond
72″ × 72″
Maker unknown
Ca. 1900
Pennsylvania

When the LaGrange County Amish community was hit by the Palm Sunday tornado in 1964, relief came from everywhere in the form of goods and labor for rebuilding. This quilt was donated to Olena and Irene Wingard, who lived in Shipshewana at that time. The Block and Diamond pattern is rarely found in Indiana Amish quilts.

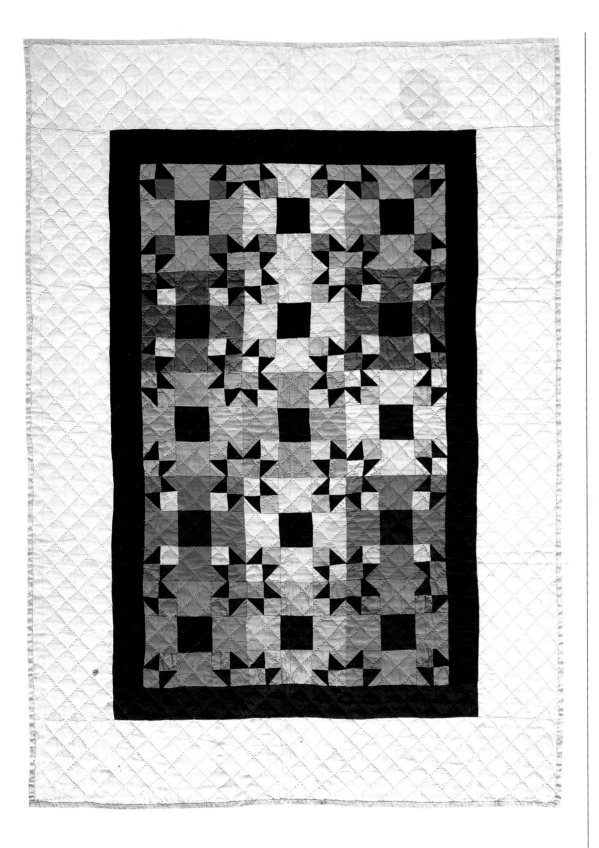

Goosefoot Crib Quilt
39″ × 28″
Amanda Bontrager Yoder
Ca. 1928
Topeka, Indiana

Amanda made this quilt
for her first son, Perry,
born May 10, 1928.

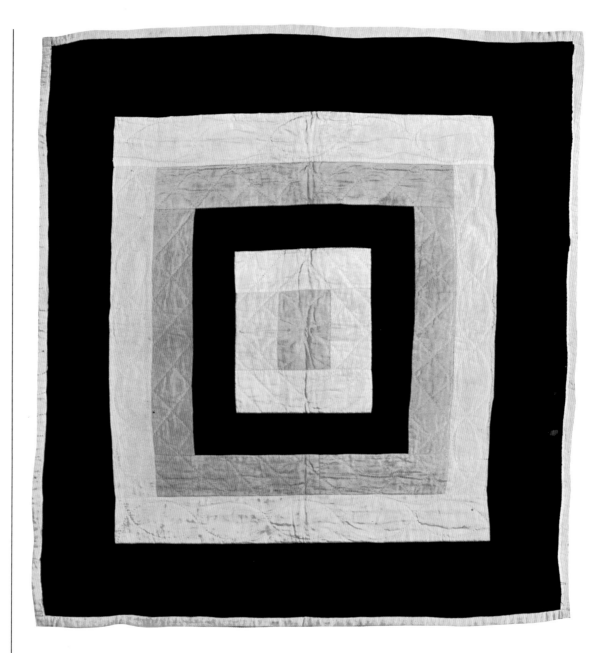

Concentric Rectangles
Crib Quilt
37" × 34"
Mattie Hostetler Bontrager
Ca. 1915
LaGrange, Indiana

Unusual for an Indiana
Amish quilt, this
particular pattern is more
typical of quilts made in
Pennsylvania and
Ohio communities.

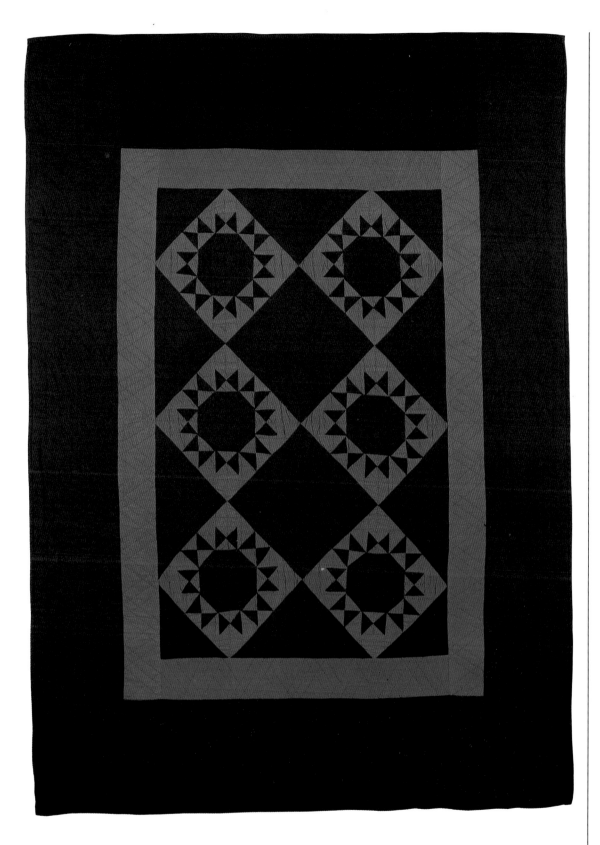

Sixteen Point Star
 Crib Quilt
54″ × 39″
Susie Miller
Ca. 1911
Topeka, Indiana

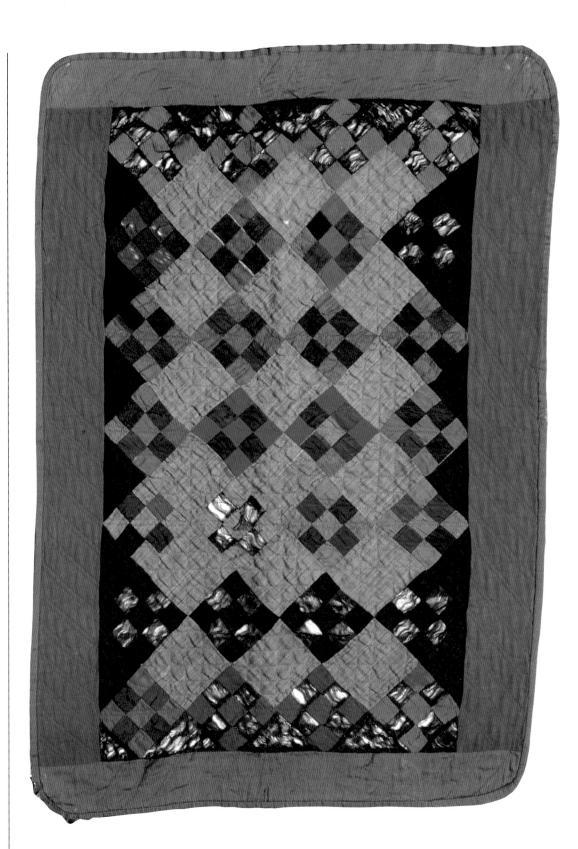

Nine Patch Crib Quilt
43″ × 29″
Mrs. Aaron Beechy
Ca. 1890
Emma, Indiana

———— AMISH STYLE

Bibliography

Gingerich, Eli E. *Indiana Amish Directory: Elkhart and LaGrange Counties.* Middlebury, Ind. 1980.

Good, Merle and Phyllis. *Twenty Most Asked Questions About the Amish and Mennonites.* Intercourse, Pa.: Good Books, 1979.

Martin, Luann K. Habegger. *Bonnets and Beards.* Berne, Ind.: Fred Von Gunten, 1971.

Miller, Devon. *Amish Directory of the Nappanee, Ko-*

komo & Milroy Communities—1985. Nappanee, Ind.

Pellman, Rachel T., and Ranck, Joanne. *Quilts Among the Plain People.* Intercourse, Pa.: Good Books, 19??.

Scott, Stephen. *Why Do They Dress That Way?* Intercourse, Pa.: Good Books, 1986.

Scott, Stephen. *The Amish Wedding.* Intercourse, Pa.: Good Books, 1988.

KATHLEEN MCLARY is Chief Curator of Cultural History, Division of Museum and Historic Sites, State of Indiana.

DAVID POTTINGER is nationally recognized for his collection and documentation of Indiana Amish artifacts.

Book and Jacket Designer

Sharon L. Sklar

Editor

Karen S. Craig

Production Coordinator

Harriet Curry

Typeface

Helvetica Light Condensed

Printer and Binder

Everbest Printing Co., Ltd.